BOOK **3** SECRETS. SIGALERTS. RAVINES. RECORDS.

PAPERBACK L.A.

A CASUAL ANTHOLOGY

EDITOR
SUSAN LaTEMPA

PROSPECT
·PARK·
BOOKS

Published by Prospect Park Books
2359 Lincoln Ave.
Altadena, CA 91001
www.prospectparkbooks.com

Distributed by Consortium
www.cbsd.com

Library of Congress Cataloging in Publication Data is on file with the Library of Congress. The following is for reference only:

Names: LaTempa, Susan
Titles: Paperback L.A. Book 3: Secrets. SigAlerts. Ravines. Records. (2019)
Identifiers: ISBN 978-1-945551-49-9 (flexibound)
Subjects: Los Angeles, Calif.; anthologies; essays; photography.

Design by Michelle Ingram (with Kathy Kikkert)
Cover photo: *110 Freeway Overpasses*, by Ann Elliott Cutting
Printed in Korea

What I do is I drive ... when I'm driving in my car—because I want to do landscapes—I just really start homing in on the trees and hills and I keep a mental picture. And that's what I do when I'm driving my car. And then I come home ... I make a rough sketch, because you know when you're driving, in front of you there's all these mountains right here. I'm seeing them right in front of me.... So, I make a mental picture and I'll make a rough sketch. Make a rough sketch, though, because if I actually sit in front of something and try to paint it, it's too limiting. So, I'm better at my imagination.

ORAL HISTORY INTERVIEW WITH ARTIST PATSSI VALDEZ, MAY 26–JUNE 2, 1999. ARCHIVES OF AMERICAN ART, SMITHSONIAN INSTITUTION.

CONTENTS

PAPERBACK L.A. BOOK 3 IS A CASUAL ANTHOLOGY.

DIRECTING THE SPOTLIGHT

An anthology editor can assume many personalities: tour guide (to be listened to or ignored), chef with tasting menu (pitching refinement or value), Love Boat activities director, Compleat Authority, and so on. In Book 1, I introduced myself as a backyard hostess and *Paperback L.A.* as a kind of patio party. But I confess that as our three-book series has unfolded, I've come to feel more like a Joel Grey–style master of ceremonies at the cabaret. I imagine myself gleefully trash-talking or song-spieling through the artistry onstage, pointing out the performers' virtues, mocking conventional wisdom, tweaking expectations.

"See, see!" I point with my walking stick, "this nineteenth-century newspaper was multicultural and protofeminist!" To introduce the next act, I announce, "This family history tells of public incidents not written about anywhere else!" I hurry to the other side of the stage, then peek out from behind the curtain, "Have you heard the one about Pico Boulevard?"

So, yes, life as the *Paperback L.A* editor is a cabaret. In part, it's the sheer excitement of being able to introduce people who haven't been hogging the microphone or monologuing at the party. And my pleasure in working on the three stand-alone volumes of *Paperback L.A.* has only grown as I've heard from readers who tell me they've been inspired to read the books we've excerpted, or find other works by an author, or learn more about a particular slice of L.A. history or culture.

Here's the lineup for *Paperback L.A. Book 3, A Casual Anthology: Secrets. SigAlerts. Ravines. Records.*

It's an honor to reprint, possibly for the first time since its publication, a seldom-seen work by Carey McWilliams, the much-studied author, the lawyer who chaired the 1943 Sleepy Lagoon Defense Committee, and, after his L.A. years, the editor of *The Nation*. As a young man, McWilliams contributed articles to the weekly magazine *Saturday Night*. His literary criticism pieces are bracingly modern and informative. In this selection, McWilliams shows his appreciation for a poet and his pique at her publisher.

On the other end of the timeline, I'm privileged to share an excerpt from an undeservedly low-profile novel of 1970s L.A. called *Sudden Rain*. Novelists often set their fictions in times of grand upheaval, such as war or migration, but Maritta Wolff's contemporary limning of the less-grand but nonetheless profound effect of changes in marriage laws on middle-class couples in L.A. is daring for its style.

As over-documented as L.A. might seem to be, it's striking how many stories have remained in the quiet backwaters of history. For example, it's well known that Central Avenue was home to jazz clubs in the mid-twentieth century, but our selection from *The Great Black Way* by R.J. Smith focuses on how Black Angelenos fought—all the way to the US Supreme Court—against the housing restrictions that created segregated districts. Or read River Garza's essay about learning traditional Tongva plank-canoe seafaring as a child in the 1990s, and you'll realize that not only has his story not been told before, it hadn't happened for centuries until his community's cultural revival.

An excerpt from Stuart Timmons's biography of activist Harry Hay expands on the long-secret story of a pioneering underground homophile organization, and on the decade before co-founder Rudi Gernreich gained international fame as an avant-garde fashion designer. And the "Dragon's Den" chapter of Lisa See's *On Gold Mountain* describes her family's hip 1930s nightclub that was frequented by a multiethnic crowd of A-listers—and yet she can find no photos. The "Dragon's Den" excerpt is one of two selections tagged "Wild Life," along with an article about the 1968 TV program *The Monkees* and its raucous beginnings.

Three pieces are highlighted as "Set to Music." In addition to *The Great Black Way* chapter, these are Warren Hill's photo essay documenting the vitality of L.A.'s current blues scene ("The Right Notes") and an excerpt from Karen Tei Yamashita's 1997 novel *Tropic of Orange* that follows a homeless sansei who draws musical inspiration from the unfolding of a colossal traffic pileup.

Another photo essay, Ann Elliot Cutting's "Motion and Stasis," conveys abstract beauty and a suspension of noise in the industrial environment—an equally unlikely source of inspiration, perhaps.

Hometown perspectives on L.A. aren't so much rare as uncelebrated, so *Paperback L.A.* celebrates the wit and warmth of several such selections. Gilbert Hernandez's oral history of Chavez Ravine encapsulates the demolition of his childhood community and the building of what came after. Lou Mathews tells a heartfelt story of a teenager's delirious joy at the terrible beauty of street racing. Commentators Patricia Freeman and Harry Shearer take on the amusing minutiae of city life. And photographer Alexandra Hedison finds a dramatic monumentality in the rough, unfinished spaces between beach and shelter in the precincts of her childhood.

INTRODUCTION
SUSAN
LaTEMPA

We close this third anthology with a classic piece by Jonathan Gold, whose death L.A. is mourning as we go to press. In this introduction to his book *Counter Intelligence: Where to Eat in the Real Los Angeles,* he distills his findings-to-date (the book was published in 2000) and the history of his method, not so much for food writing, but for exploring Los Angeles. He offers readers dislocation and change as givens; what he doesn't do is tell readers to stay home to hide from a city that may seem "endless and illogical."

That's how it is. Time for me to twirl my silver-tipped walking stick and give a Day of the Dead kind of grin. Come to the cabaret. Dude.

SUSAN LaTEMPA
LOS ANGELES, 2018

P.S. We might be casual, but we set ourselves a pretty tight schedule for producing the *Paperback L.A.* series. Thank you to the smart, steady staff at the remarkable literary house that is Prospect Park Books—Colleen Dunn Bates, Dorie Bailey, Caitlin Ek, and Katelyn Keating, along with freelancers Michelle Ingram DeLong, Leilah Bernstein, and Margery L. Schwartz.

Next time you have a rough day, consider Charles A. Storke's day back in 1873, when the publisher-editor was working on the first issue of the *Daily Herald*. At a time when the population of L.A. County was just above 15,000, and of the city around 6,000 people, there were already a dozen papers competing for a diverse pool of readers. On this first day, his paper's announcements included a confession that with (actual) wires down, there were no stories from San Francisco, where, presumably, all the action was. Also, a *female* typesetting apprentice had apparently been the subject of pre-launch criticism, so a defensive and yet unapologetic editorial note joined the breaking news on Page 2 (Page 1 being given over to ads, letters, and poetry). Still, Storke had already excited public attention with windowed storefront offices. People gathered on the sidewalk outside to watch the steam-driven press at work. And the first issue carried a healthy amount of advertising. The *Herald* lasted, through mergers and takeovers, until 1989, when, in its final incarnation as the *Los Angeles Herald Examiner*, it folded.

PAPER CLIPS
NEWS OF THE '70S

EXCERPTS FROM LOS ANGELES DAILY HERALD

NUMBER 1. VOLUME 1. LOS ANGELES, THURSDAY, OCTOBER 2, 1873

PAGE ONE: LETTER TO THE EDITOR
The Currency Question

EDITOR HERALD: IN THE TWO GREAT DIVISIONS OF our country—Atlantic and Pacific—there are two separate and distinct currencies. Now the question arises: Which is the most beneficial to the people of the Pacific Slope? An illustration of a matter of purchase will, possibly, save a waste of words. A merchant in Los Angeles sends east for goods, for which he pays greenbacks. He goes to New York or Philadelphia with $10,000 in coin, which he exchanges for greenbacks at a discount of say 15 per cent., or $1,500. He purchases his stock, sends it to California, and sells at coin rates. In addition to the 15 per cent. profit on exchange, he realizes the same amount on sales, making 30 per cent., taking 15 per cent. as the minimum of profit.

In ordinary commercial transactions, 20 per cent. on cost is regarded a very good profit on goods of every description, but there is still another "per cent." I allude to the "value" of the coin itself. You cannot buy a dollar' s worth of anything for a dollar. Our dealers reckon their sums by "bits," or 12½ cents. As the Government recognizes no such coin, dealers must certainly put a fictitious value on their wares. If you want to buy 20 yards of

muslin at a "bit" a yard, you must pay $2.50 for it, unless you pay in dimes, twenty of which will be refused by the dealer as an insufficient sum. But the same dealer will accept a dime for a "bit" or 12 ½ cents, in the purchase of any one article of that price. Again; if you wish change for a half-dollar, nine out of every ten dealers will give but *four* instead of five dimes or "bits" for it.

Now, the man of limited means will naturally conclude that there is something wrong somewhere with this financial system. A dollar ought to be a dollar everywhere. But the common style of dealing actually reduces the value of one dollar in coin *twenty per cent.*, and of greenbacks *thirty-five per cent.* Now, if the same currency, be it coin or paper, were used all over the United States, it would be beneficial to all classes, more particularly to those from whom the direct support of the Government comes—the men of limited means. Men of capital can, with less sense of loss, submit to this rate of exchange (if I may call it by so mild a name); but, with this system, there is little or no opportunity for a small capital to increase itself. These ideas, and the manner of their explanation, may seem crude; but the fact as stated remains, and it is for our legislators, and others, who command the capital and control the interests of the masses, to remedy this evil.

GREENBACKS.

PAGE TWO: A YOUNG LADY

A young lady has entered the Los Angeles HERALD office for the purpose of learning type-setting, proof reading and possibly, in course of time, journalism. She is one of the class who prefer the pleasures of occupation to idleness, social shams, servile dependence. Even woman, be she rich or poor, ought to be a useful worker in the struggle of life, whether in the family relation or out of it. Her health and happiness depend upon it. To attain a certain Individuality and independence and yet retain her womanly qualities—a happy medium—is woman's true mission. To accomplish it she must be permitted to enter all suitable fields of Industry. Her normal position is in home and family, but the conditions of society in these times require her to prepare for self-sustenance. If home and family do not exist for her, it is her right and duty to pursue any calling adapted to her sex and to earn for herself an honorable livelihood. Where, aside from domestic duties, can woman's fingers be used with greater advantage than in setting type? Where can her brain receive a quicker and broader impulse than in being brought in daily contact with the living thought of the world?

PAGE THREE: THE DAY OF ATONEMENT

Amongst the members of the Jewish faith commences on the tenth day of the seventh month of *Tishiri*. With this day ends the season of penance. The authority for the fast is the scriptural command in the Law "on the tenth day of the seventh month, is the day of atonement; it shall be to you a day of holy convocation; and ye shall afflict your souls (by fasting). Ye shall do no work on that same day; for it Is a day of atonement, on which you shall be pardoned before the Eternal, your God."

During the existence of the Temple in Jerusalem, the High Priest entered the Holy of Holies on this one day only. The whole nation fasted and prayed, and the priests were continuously engaged in their ministrations. The ceremonies conclude on the evening of the tenth day with the assurance of the Rabbi to his flock "ye are pure," and they return home happy. The celebration of the day of atonement this year commenced on Tuesday last at sundown, and lasted till Wednesday at the same hour. For the first time our Jewish citizens celebrated this day in their new synagogue, and the sacred ceremonies were participated in by a large and earnest congregation.

The following is the substance of the Rev. Mr. Edelman's discourse [. . .]

The prevailing color of the ladies' toilettes was white, whilst many of the gentlemen of the congregation wore white silk scarfs around their shoulders.

At the conclusion of the sermon a Psalm was sung antiphonally by a choir of children and the Rabbi.

PAGE THREE: THE COURTS

COUNTY COURT—Hon. Y. Sepulveda, J. October 1—**David Lewis vs. David Anderson**. Continued until today.

Rivara vs. Pelanconi. Leave given to file amended answer.

Lehman vs. Taylor. Decree of foreclosure entered.

Sotelo vs. Chavs. Findings filed and interlocutory decree entered. Adjourned until 10 A. M. to-day.

CITY COURT—Hon. J.R. Toberman, Mayor. October 1—There were only four cases before the Mayor yesterday, to answer the charges of drunk and disorderly. Although the assessments were small, they were committed for want of ducats to meet the moderate demand and were thrust back into jail, to issue thence in the chain-gang.

PAGE FOUR: ADVERTISEMENTS

In 1948, Don Normark, a "skinny man with a box camera who didn't speak Spanish," as *L.A. Times* obit writer Elaine Woo put it, made multiple visits to the communities of Chavez Ravine. He was a photography student at ArtCenter, drawn to this group of three rural Mexican-American neighborhoods by its similarity to the Hoogdal, Washington, enclave where his Swedish grandparents lived. He came for a class assignment and returned often for months, welcomed as he took hundreds of photos of everyday neighborhood life. When the 1,000 resident families were forced out in the 1950s (losers in a series of political power struggles), Normark had moved away, but he returned in the 1990s as a retiree and painstakingly gathered oral histories from the people he'd photographed as children. Their voices are remarkable for their pragmatism, their knowledge imbibed through deep local roots, and their ongoing connection with the layered landscape.

URBAN PIONEERS
ORAL HISTORY

CHAVEZ RAVINE, 1949: A LOS ANGELES STORY

DON NORMARK

GILBERT HERNANDEZ: THE HOUSES THAT WERE EMPTY,
they came and knocked them down, then cleared the land, except for the Arechigas and the Davidsons. In 1959 I was working for J. Thompson Construction Company. We had the contract to move the dirt for Dodger Stadium. Nine million yards to be moved in one year. That job was subbed to Vanil Construction Company. Tomay did the fine grade, Southwest Paving did the pavements, and some company from New York built the stadium. Ballan poured all the concrete when they put in Stadium Way from Riverside Drive. The lot where I was born is still there. They didn't mess it. The land of La Loma is still there. The lots are landscaped with ice plants and palm trees now. The reservoir on top is still there. With that as reference, I can tell where our house was and where Effie was. Paducah, Malvina, Reposa, Davis: I remember the streets of Palo Verde. And in La Loma, Pine Street, Yolo Drive, Spruce Avenue, and Brooks Avenue, where we lived. I can remember all of the streets just like a dream. I can close my eyes and see how it looked. Everybody lived so happy there. Back in the hills where they built Dodger Stadium, we made model airplanes and kites and flew them up on top. From that hill, you could see Santa Monica, Playa del Rey, and all the ocean.

Davidson Brick Company was there many years back. My grandfather

and uncle hauled the imperfect bricks to their house to build the driveway. The sidewalks by my grandfather's house in the back and in front were all brick.

I liked to sit and listen to my grandfather. He said we came from Mexico in 1905 when my father was five years old. My grandfather's name was Bruno Hernandez. He tried three times to come into California. He came to El Paso, Juárez, and crossed Arizona, but he couldn't make it; too far and bad desert. Then Nogales; desert again. Finally, he came through Mexicali, the Salton Sea, Calexico, through there. Palm Springs. Mexicali was just a dinky border town, and Palm Springs was nothing. There was a wagon trail which they traveled on through San Bernardino to Colton. They stopped in Colton, where the railroad was being built, and again in Culver City, which was all ranches and swamps. They came on horseback with a wagon.

In 1911 they got to Los Angeles and found some land in the Chavez Ravine. The lots were on Brooks Avenue in La Loma. My uncle Domingo built a house there, my grandfather built a house, and then my Tío Candelario and my Tía Natalia came. My uncle Domingo's address was 1726. The address where I was born was 1724; my other uncle's house was 1714; and my aunt's was 1716. My oldest daughter was born at 1716, and my other daughters were born right on the corner across the street. My wife, Tepi, was born in the same block. We were married at Santo Niño Church by Father Tomás on August 30, 1945.

When my dad passed away in 1937, he was thirty-seven years old. We were very poor. My mother passed away in 1940. When Roosevelt became president, he put in the welfare program. They gave us shirts and shoes and corduroy pants, but everything was a dark green. At school, everyone knew who was on the relief. Kids would say, "He is from the 'gimme gimme' look!" I felt embarrassed about it.

We picked apricots in May. In June, tomatoes and cucumbers and all the work on the farms. We would pick the grapes in August. Walnuts would start in September. To me it was a lot of fun. To my friends it wasn't. From Burbank all the way to Chatsworth was nothing but farmland, walnuts. Now there are only a lot of houses.

The streetcars were good. One Red Car went to Canoga Park. Another Red Car went all the way down to San Dimas, Arcadia, Monrovia, and Azusa, and another one to Long Beach and to Santa Monica. The number 5W Yellow cars went to Eagle Rock, Mt. Washington, and Cypress. The Main car went to Lincoln Park. The V car went to Spring and Sunset. Fare was seven

cents. The Red streetcars were a dime. Sometimes we'd ride to the end of the line and stay in our seats and ride back. They wouldn't charge you if you didn't get off the car. They went down the aisle, bang, bang, bang, flipping the seats so they faced the other end. The conductor would get off and pull the cable down and wrap it up and then transfer his coin box to the front end. It was a lot of fun. I went on the streetcars to school.

My dad worked in a laundry for many years and so did my uncle Domingo. My uncle Candelario worked for the Yellow Transit streetcar company. My grandfather was old then and didn't work. He would pick up pieces of metal or rags, anything he could sell. When we'd leave to pick grapes, he would come with us. When I started getting paid by the hour in 1944, they gave me thirty-five cents an hour. When I retired in 1990, I was making thirty-five dollars an hour.

Carey McWilliams, lawyer, editor, and author of many books, including *Southern California: An Island on the Land,* seems to have been one of those young writers who, while confident in his own taste and judgment, also prepared assiduously and read widely. Reading a seldom-seen trove of magazine articles he wrote in his early twenties is a pleasure nearly a century later. His series on Southern California writers for *Saturday Night,* a weekly magazine published in Los Angeles in the 1920s and '30s, is rich with references and insight. He writes with a Jazz Age brio that is gracefully erudite today. In this piece about poet Hildegarde Flanner, published on January 19, 1929, Mc-Williams rants against limited editions with arguments that reflect his knowledge of the world of book collectors, hinting at the gentility trap facing wealthy white women in literature. *Saturday Night* was sent to subscribers by mail and sold at "all prominent newsstands, bookstores and hotels in Los Angeles, San Francisco, and Pasadena" as well as at Brentano's in New York and Paris, and at W.H. Smith & Son in Paris, London, and Stratford-upon-Avon.

CRITIC'S LAMENT
POET PROFILE

SOUTHERN CALIFORNIA BEGINS TO WRITE: HILDEGARDE FLANNER

CAREY McWILLIAMS

FINE PRINTING HAS ITS MANY OBVIOUS POINTS BUT, perhaps, its most marked limitation—surely it is the most annoying—is a certain suggestion of the esoteric. It seems to be a tenet of all excellent printing that it must not be done in any quantity that will suggest the possibility of a democratic appreciation of fine values; in fact, one is led to suspect that the printers make a virtue of exclusiveness itself. Certainly, these limited editions are enough to make one curse all fine printing at times. Readers familiar with the fine quality of Hildegarde Flanner's magazine verse have doubtless tried to obtain copies of "A Tree in Bloom" or "This Morning," and have, perhaps, abandoned the chase with much mutterings against limited editions and fine but fugitive printing. This difficulty will be remedied when Macmillan brings out a new volume containing much of the earlier, and heretofore inaccessible, work of Hildegarde Flanner.

Hildegarde Flanner's verse has been appearing in poetry magazines now for a number of years. Local theatergoers will recall her play "Mansions," which was originally written for a play-writing class at the University of California, conducted by Sam Hume. It was at Berkeley, too, that she studied verse-writing under Witter Bynner, who had not then signed the Debts Protest and was still allowed to teach and to dine at the Bohemian Club in comparative peace. "Mansions" has been produced locally several times and has

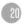

been printed in a collection of modern plays published by Appleton's. Besides this play there have been several volumes of verse, published in fine editions limited in number. Of these, "This Morning" and "A Tree in Bloom" have already been mentioned. She has published, also, "That Endeth Never," a story, the printing of which was the work of Mr. Porter Garnett. Only fifty-two copies of this publication were issued, and the drawings, casts, matrices, and plates were destroyed and the type distributed after publication to make sure that there would be no future editions! "Young Girl" is another book which was issued by Porter Garnett. Hildegarde Flanner lives in Altadena, and is the wife of Frederick Monhoff, who has done the decorations for her new volume of verse to be published by Macmillan.

It would be an act of supererogation to attempt a mystical analysis of the work of such a poet as Hildegarde Flanner, outlining influences, defining dominant qualities, and suggesting possible avenues of development. Few modern poets actually merit such consideration in the first place, and again any such criticism tends inevitably to become specious, highsounding, and empty. When a poet has a half dozen volumes published, it is then time enough to sit down and do the usual critique, but with new poets this method is obviously impossible and highly undesirable.

I would simply offer, then, a few of Hildegarde Flanner's poems, and I think their quotation will obviate any necessity of taking a maestro's baton and pointing out their many excellent qualities. The following lyric is taken from *Palms* [a poetry magazine published 1923–1940], November 1927:

> Your body, being distant, has grown dim to me.
> Too many long horizons, like blue dragons
> Guard you in towers of invisibility.
> I have no charm against these dragons.
>
> Faintly your face is shimmering in my mind
> Like a shell far down in water.
> I cannot draw you up to me, nor find
> The green way down to you through water.
>
> Come to me suddenly with a great rush,
> That I may open startled eyes on yours
> And barely lean against you in the hush
> Of my soul laying timid hands on yours.

It is verse-writing ability such as this that makes one watch the spring lists of Macmillan's so eagerly.

But finer still are these two "California Poems" taken from *The Nation* of a recent date:

SUMMER'S END

The sound of summer slipping from the trees
Is scarcely heard in this bright land.
The heavy fig-leaves falling to the ground
Make a nearly summerless and yellow sound.
But the pearly fig-tree with its linnets
Soft as roses on the marble twig,
Dismisses summer only to invite
A snowless winter to its arms of white.
And winter comes, with her unsleeping flowers—
Or is it spring, that flashes and is here?
Or is it both lie dreaming in one place
And rise bewildered, face to face?

THE OWL

The sweet and ghostly laughter of the owl
Last night shook upward from the light bamboo.
The garden rose and trembled at the sound,
Suspended in enchantment and in dew.
With strange reversal of the blood and soul,
What dizzying floating upward from the earth,
When suddenly the darkness broke in two
Upon the honeyed edge of this soft mirth,
And in its wake a glint of mockery
Unbearable to hearts worn out with prayer.
For man, asleep, still labors over fear
The dreamless owl abandons to the air.

On Gold Mountain, Lisa See's gracefully written 1995 family history, follows multiple narrative paths. As she tracks, for more than a century, the clan engendered by her ancestor Fong See, she brings passed-down family tales and contemporary interviews to life. Her characters are her grandparents, great-aunts and -uncles, and their parents and grandparents. Her setting is largely Lo Sang, Los Angeles. She captures ways that big changes in world history impact individuals, as well as the mood at various moments in L.A. from a particular Chinese-American perspective. This selection begins in the 1930s, with Eddy, one of Fong See's twelve children, hanging with his art-school friends Tyrus Wong, later a Disney animator and celebrated artist, and George Stanley, who sculpted the Oscar statuette and the Muse at Hollywood Bowl.

WILD LIFE 1
DRAGON'S DEN

ON GOLD MOUNTAIN
THE ONE-HUNDRED-YEAR ODYSSEY OF MY CHINESE-AMERICAN FAMILY

LISA SEE

FROM "DEPRESSION 1929–34"

"COME ON, STAY," TYRUS WONG SAID ONE FINAL TIME, as he walked over to the table to help with dinner.

"Okay," George Stanley answered, pulling up a chair and sitting down.

Eddy smiled. He should have been the one doing the inviting, not Tyrus, but what the hell. What mattered was they were down in the basement of the store, hanging out and putting together a cheap meal. Over the last few months, Eddy had become good friends with Tyrus Wong and Benji Okubo, two students from Otis Art School who'd originally come down to the store to look at art. Tonight they'd brought along George Stanley, an aspiring sculptor. He'd been standing around looking dignified and nervous. Tyrus had been cajoling him to stay, but George couldn't make up his mind.

Tyrus cracked a salted egg to separate the white from the hard yolk. He squeezed a little too hard, and the yolk flipped up into the air, landed, and rolled across the dirty cement floor. Tyrus picked up the yolk and carried it over to the sink to wash it off. George abruptly stood up again, and said, "Oh, I just thought of something. I have an engagement. I have to leave."

As soon as George left, they fell over laughing.

"The way the egg went *flit*!" Tyrus giggled. "It's like a gold ball rolling

across the floor."

"I have an engagement," Eddy hooted.

The more they replayed the scene, the funnier it got.

Eddy loved being back in Chinatown. There was something about it that you just didn't get out in the other world. Of course, everyone interpreted Chinatown through their own eyes. Reporters got a kick out of it. They weren't just satisfied with tong wars, opium smuggling, prostitution, and gambling. One reporter in town for *The New York Times* had called Chinatown "a dark, crowded section, hot and thick, as full of mysterious ingredients as chili con carne, and as quick to burn." The old Plaza, which lay directly across the street from the store, was "a hotbed of vivid, violent life, as fertile as Hollywood is sterile."

This wasn't the world Eddy saw every day. He felt more like Louise Leung, the daughter of one of the city's most respected herbalists, who'd gone to USC and was the only Chinese working as a reporter at the *Los Angeles Times*. Recently she'd written an article titled "Please, What Am I? Chinese or American?" She described how she ate toast and eggs and coffee for breakfast, and rice, fried tofu, and spareribs for dinner; how she wore western clothes, but her friends at the paper thought she should wear Chinese clothes; how her parents had never tasted cheese or butter, considering these dairy products an abomination. Eddy thought that Louise had done a good job of illustrating the delicate balance between the two cultures. Like Louise, Eddy also wondered how a person could place himself.

So many of the old traditions and prejudices still held true. Sure, a guy could graduate from college, but no American company was going to hire a Chinese. A few were polite about it, but most weren't. It was like those restaurants that posted signs that read "No dogs, Orientals, or colored allowed," or the movie theaters where the cashiers hung up Sold Out signs when a Chinese walked up to the window.

Eddy knew he didn't belong *out there*. But did he belong here? He was happiest in Chinatown, hanging out with Benji and Tyrus, and yet....

Eddy also had friends like George Wong. He'd come down from San Francisco in 1929, opened a fish and poultry store east of Alameda, then moved up to Spring Street after the demolition. He had an attitude about Caucasians that was different from the prevailing view when Eddy was growing up. "Caucasians are always coming into Chinatown to steal and rob," George would say. "They come down here and take our pictures without asking us.

I don't like that. Then the Caucasian says, 'Who in the hell do you think you are?' I say, 'I told you once. Don't do it. *Don't do it!* You do it one more time, you better get out of Chinatown—fast!' Then they send us their policemen. There's one who's too sassy. He's always looking down at us and calling us 'yellow.'"

Sometimes George would act out what he wanted to say to the policeman, brandishing an imaginary knife: "You want to start a fight? Come on. *I'll* change your mind." After some Chinese guys had gotten together and attacked the policeman, George scoffed, "The only difference between that policeman and us is that he wears a badge. If he were here today, I'd say, 'Don't call me Chinaman. Don't say anything about my straight black hair. My hair is the same as your hair. Don't say anything bad about Chinese people, or don't come back to Chinatown.' That policeman was lucky that day he got beat up. When in America, you follow American law, but if you insult me, don't come to Chinatown!"

Even though George didn't like Caucasians, he got along with the See family. "You're half and half," he said. "You don't cause trouble." George was hot-tempered but a good guy.

To Eddy, coming back to Chinatown had also meant seeing more of his father. This year, 1934, Fong See had bought all of the children from the first family matching four-door Plymouths. These were hardly the low-slung beauties that Ming and Ray [Eddy's older brothers] had grown up with, but Eddy had read the gifts as a kind of peace offering. [. . .]

But Eddy was at loose ends. His job at the factory hadn't worked out. His mind drifted when he spent the day running wood through a table saw. It drifted so much, in fact, that he'd lost a few fingers. Now, at twenty-eight, Eddy was making jewelry, learning from the man who owned the Jin Hing Jewelry Store, and spending the rest of his time in the store with his mother and Ming.

Business at the F. Suie One Company had changed. Merchandise [Chinese antiques and imports] now settled into three categories: one-third for collectors, one-third for movie rentals, and one-third that the family planned to keep forever. Movie rentals were currently the most lucrative aspect of the business—if anything could be considered lucrative these days. Since the release of *Broken Blossoms* in 1919, the F. Suie One and F. See On companies had rented steadily to the studios. The films *Shanghai Express*, in 1932, and *The Bitter Tea of General Yen*, in 1933, had recently brought in particularly good revenue. Ma didn't like to deal with set decorators, because they were,

according to her, "a rough-and-tumble lot." So it fell to the boys to deal with the studios. But Eddy, as the youngest son, was consistently left out of these business dealings. [. . .]

As far as work was concerned, everyone talked about Ray's dreams, Ming's dreams, but no one ever thought about Eddy that way. He had dreams. He often fantasized about the life he could have had if he'd stayed in China in 1919. He'd be wealthy, powerful, always in touch with his father instead of just seeing him walk past the store every day and watching his mother pretend to be on the lookout for the mailman while everyone—and he meant *everyone* in Chinatown—knew that she was pining for him. Eddy had a vision of life that involved art and beauty, but Eddy wasn't an artist. Oh, he was handy, all right. Everyone in Chinatown knew they could come to him to fix a broken lamp or make a picture frame, but that wasn't the same as actually creating something.

Then he'd met up with Benji and this whole art group. Benji Okubo was a Japanese guy—strange, loony, bohemian. He'd grown up in Riverside, then studied art at Otis on scholarship, earning his keep as a busboy in the cafeteria, mopping the floors and taking home leftovers for dinner. He wore long sideburns that he twisted into spit curls. He liked to tuck his collar under, and wear his shirt open down to his navel. Sometimes he wore an ankle-length overcoat, and stood with his arms crossed, looking foreboding. Now he divided his time between the Art Students' League and a barn off Alvarado where he taught painting.

Tyrus was born in China but had been around Chinatown for a long time. He was a scrawny little guy and talked like a character in a movie. He was funny, and a great artist. Tyrus lived with his father—a lookout for a gambling den—in one of the boardinghouses for single men. Tyrus had started dropping by the store, and soon Ma had begun asking him, "Have you eaten yet?" Tyrus had stayed, and they'd become fast friends.

Then there was Eddy. He had a loose way about him. He liked his clothes on the baggy side to allow for expansive gestures and to have the freedom to perform whatever task someone asked of him. He was certainly huskier than Tyrus. Eddy's hair was unruly and long, but hardly the wild cut that Benji preferred. And while Benji had those spit curls, Eddy had grown a goatee.

If anything tied them together, it was their admiration for the artist Stanton MacDonald-Wright, who had founded the school of Synchromy in Paris with his friend Morgan Russell. MacDonald-Wright had eventually abandoned Synchromy, claiming it had become stultifying to him, and moved back to California to take over the Art Students' League. The artist—who was

now using Chinese and Japanese motifs in his own work—encouraged his Asian students to look to their roots for inspiration. But when Eddy looked at the work, he wondered who was influencing whom—MacDonald-Wright his students, or the students their teacher.

So here were all of these Asian artists and artists inspired by Asian art, and no one paid attention to them. Sure, some of them, like Tyrus, worked for the WPA. But it wasn't the same as *acknowledging* them. This was where Eddy's idea of work came in. Eddy talked to his mother and Milton. "We have the mezzanine," he said. "Customers don't go up there. It's not a great place to show merchandise. We could open a gallery."

The first exhibit featured Tyrus's work—lithographs, prints, and paintings. Then Eddy mounted a combined show with Benji, Tyrus, Stanton MacDonald-Wright, and three other artists, Hideo Date, Jake Zeitlin, and Jimmy Redmond. The show had been so successful that the Community Arts Association, Public Library, and Art Gallery of Palos Verdes Estates had sponsored another. The gang had all snickered over that show's brochure, which praised Tyrus as an "ardent admirer of Michael Angelo [sic], El Greco, and the Chinese masters of old." Next April, Hideo, Benji, and Tyrus would have an exhibit at the Los Angeles County Museum of Art.

But they were all still stone broke, which was why most nights—like tonight—the gang came to the store and went downstairs to the basement to hang out and eat. Most evenings they only had enough money to make *fan jiu*, crusty rice boiled in water, flavored with a little "bug juice," Benji's name for soy sauce.

"Hey, Benji, you know that girl, that Caucasian girl, who went to Otis for a while?" Tyrus asked. "She tells me she wants to be seduced by Wright. Why not? All the girls want to go to bed with him. She goes over to the Art Students' League. You know what happens?"

"We're going to hear about it whether we like it or not," Benji said.

"That guy's so smooth. He says to her, 'God created millions and millions of little girls. Will this one little girl be a little bit naughty?'"

Everyone laughed, and Tyrus went on, "I say to her, 'What's the highlight?' She says, 'He wore silk stockings.'"

"Silk stockings?" Eddy asked.

Tyrus moved on in his typical jumpy style, telling a story that they'd heard before. "Everyone knows that it's the thing to make sketching trips to Mexico. It's only two or three hours away, and then you're in a foreign country. The scenery, the colors, everything is different. My friend says, 'Let's go to Mexico

for the day.' I think, he's got a big black Packard, what the hell? So we're coming back across the border and I don't have my papers. The immigration man says, 'You have to go to Mexicali.' That's a hell of a long way, you know? My friend, his wife, his daughter—they're all in the front seat. We're driving through desert and I'm as sick as a village dog. We get to Mexicali. They say, 'No, no, no. You have to go through Tijuana.' I go back there and wait and wait. I'm there for about a month."

"You weren't incarcerated," Benji interrupted. "You were free to roam around. Did you sketch?"

"I couldn't! I was too scared!"

"A Chinese family befriended you," Eddy said. "They took you home."

"Yeah," said Benji, winking. "And they had a daughter."

A lot of this badinage was to keep Tyrus from brooding about a Chinese girl who worked in the drugstore down the street. He'd told them how he'd spotted her in a bookstore and been smitten. He'd asked a friend if he knew her.

"That's Ruth," his friend had told him. "She won't be interested in you. She went to UCLA, and you didn't even finish junior high."

"I'm going to ask her out anyway," Tyrus had responded. Later he'd gone up to Ruth and said, "Can I buy you an ice cream cone?"

"No thank you," was all she'd said, and turned away.

Tyrus's friend was smug: "I told you she wouldn't be interested in you. I told you, and you wouldn't listen."

Eddy and Benji tried to keep Tyrus off the subject of Ruth, because if she came up he would gloomily repeat over and over again, "Geez, I'm hit with a sledgehammer." As an artist, you didn't have to worry too much about fitting in and being American, Eddy thought, but you could still worry about getting the girl.

Drink? Women? Work? None of these things interested Eddy that much. He loved a dumb joke, preferably a dumb dirty joke. He loved hanging out with his pals and trading silly stories. He loved to have fun. Now all he had to do was figure out a way to have fun and do a job that he liked.

FROM "DRAGON'S DEN 1934–35"

Sometimes—perhaps just once in a century, if a family is lucky enough—there comes a time that appears perfect. It lives on in dreams and memories. It's seductive to children and grandchildren who wish they could have been there. It's a time filled with exotic and interesting people dressed in exquisite clothes,

who speak in the sultry voices of romance and intrigue. It's a place where people use ivory cigarette holders, drink, and act elegant, and nothing bad ever happens to them. It's a place that's mostly found in the movies, but for a few short years became the domain of Eddy See and his cohorts.

It began on a night in late 1934, with dinner in the basement of the F. Suie One Company on Los Angeles Street, and a conversation that is as mysterious and elusive as Dragon's Den itself. Eddy, the youngest son of Ticie and Fong See, probably would have been stirring up some tomato beef on the hot plate. Stella, Eddy's wife, would have been keeping four-year-old Richard amused. Tyrus Wong and Benji Okubo would have pulled down the table that hung from the ceiling, and Sissee would have gotten out the chopsticks and bowls. Later, as they lingered over fragrant cups of tea, their talk would have turned inevitably to art, dreams, and fortunes not yet made.

"Eddy, you should have another show upstairs," Tyrus said.

"Yeah, it was good for *you*," Eddy answered in his teasing way. "I hung the damn thing. I did the work. You guys got the glory."

"*You* did the work?" Benji snorted.

"It was a great show," Eddy said. "It was good work. But listen, there's no money in it."

They pondered that for a while. Art was great, but could you make money at it? Benji certainly didn't have what anyone could call a livelihood. Tyrus had been a prodigy at Otis, but they'd all been entertained by his tales of trying to earn a living as an artist. Sissee was still working at the weather-stripping company for two dollars a day. Stella had given up her fledgling career as a commercial artist to become a full-time mother. And Eddy? The gallery up on the mezzanine wasn't going to put bread on the table. It was like the store in that way. People still loved art, loved beautiful things, but no one had money to spend on luxuries.

"We have to figure out what people need," Eddy said.

"Sex," offered Benji. "You take the wife and I'll take the sex." They had heard this line from him before.

"Food," suggested Tyrus. They all laughed because he'd always been skinny. Then Sissee echoed, "Food."

There was something in the way she said the word—so soft, so considered— that Eddy said, "Hey, let's open a restaurant."

At first it seemed out of the realm of possibility, but as they talked it began to make sense.

"What's the competition?" Eddy asked. "There's Soochow, Man Gen Low,

Tuey Far Low, Grand East, and Grand View. Then there's Yee Yung Gooey—a total disaster as far as an American name for a restaurant." They all thought about that place. The kitchen was exposed, sawdust lay on the floor, and customers selected their chopsticks from a dirty glass set on the table. No amenities, just a place where single men could get the soup of the house, a single main dish, a bowl of rice, and tea for twenty-five cents.

"There's Jerry's Joynt for ribs, steak, and lobster—American stuff," Sissee said.

"I like Sam Yuen and See Yuen," Tyrus added. Both restaurants served American food to Chinese families. The meals at these establishments were also cheap—roast pork, roast beef, soup with oyster crackers, coffee, fresh pie, and homemade salt-rising bread, all for just twenty-five cents, or thirty-five cents for a T-bone steak.

Someone mentioned that the Paris Café, a Chinese-owned establishment in the Garnier Building, had gone out of business, while the Paris Inn, an Italian restaurant, was still popular.

"What about the chop suey joints?" Stella asked.

"We won't count those."

"Okay, maybe seven good places that serve family-style meals in Chinatown," Eddy said. "We would be number eight in the city, but we would be the best. We'll have the best food. And look, I'm half *lo fan*! We'll be the restaurant for Caucasians. We'll cater to them."

"I wonder if we could really pull it off," Stella said.

Eddy went on. "This isn't going to be just another place. It has to be *the* place. We'll get in the society columns. We'll bring in the Hollywood crowd." Looking at the disbelieving faces, he asked, "Well, why not?"

No one had an answer. Then Benji muttered one syllable: "Art." Of course, that was it. Art would make this restaurant different.

"Benji can do murals," Eddy said. "Tyrus will help." And in those sentences the boss and his helper were established.

"I'll need more than Tyrus."

"Okay, so you'll have more," Eddy reassured him.

"So, Eddy, where's it going to be?" Tyrus asked.

"Right here, Tyrus. Right here." They looked around the basement at the bare brick walls dark with age, the exposed floor joists, the huge water pipes running along the ceiling, and the large gate valve in the center to turn the water on and off. Some might have been daunted, but this group was thrilled. Benji pushed away the remains of dinner, pulled out some paper, and began sketching. Ideas expanded and grew.

"We could knock down this wall," Eddy said, thinking aloud.

"Good job for Tyrus," Benji said.

"I'll draw new menus every night," Tyrus suggested.

"First you knock down the wall, then you do the menus."

"I could be the hostess," Sissee offered.

"We'll have ice cream," Eddy said. "Not the regular flavors, but lichee and ginger. We'll find someone to make those up. No one in the city has ever had those flavors. They'll be unique to us. We'll call the place Dragon's Den."

"Long Gam Low," Tyrus translated.

The gang worked on the plan until they felt it was ready to show to Eddy's eldest brother for approval. Ming thought it was a bad idea.

"You don't know anything about the restaurant business," Ming pointed out. "That's a basement. No one wants to go to a basement to eat. No one wants to go downstairs. People like to go upstairs. They like nice places, not places filled with rats and dirt."

At that, Ticie intervened. "Ming will give you the money."

"Six hundred dollars, and not a penny more."

That six hundred dollars—a fortune miraculously saved by the family during those cash-lean years—went a long way. Eddy borrowed two large marble Foo dogs from the store for the entrance. See Manufacturing made up tables and chairs, a cabinet to hold hats and coats, a cashier's desk, and room dividers, all at cost. The furniture was done in pseudo-Chinese fashion: carved designs decorated the backs of the chairs; blue and white ceramic fish were used as pulls on the hat cabinet. The kitchen was outfitted with huge woks and a deep double sink. Dishes were purchased in bulk through the store. With Prohibition still on, the area that could have held a little bar—a freight elevator that led to the sidewalk—was converted to Eddy's ice cream bar. He hired two waiters and two waitresses at a dollar a day, plus tips. He found four men to work in the kitchen—a head cook, a second cook, a fry cook, and a prep man. He hired others as dishwashers. The kitchen help would receive between forty and sixty dollars a month.

When the tongs came calling, offering protection, Eddy said, "You can kill me or do whatever you want, but just remember I have three brothers. No matter what happens, they'll come and get you." Later when his friend told him how stupid he'd been, Eddy shot back, "Fuck the tong. If you have enough people to back you up, you don't need them. Besides, they're not as strong as they used to be." Everyone hoped he was right.

Eddy let the artists conceive the overall design. Tyrus spent days knocking

through the wall that divided the two dining rooms, leaving the edges jagged so that it looked like a dragon's den. Another friend from art school, Marian Blanchard, painted the rough edges. In the end, people would laughingly remember that the most money was spent on paint. Gallon after gallon of primer, followed by imperial yellow enamel, sank into the porous brick. Again and again, Eddy went out for more cans of Du Pont Deluxe.

Benji's perfectionism showed itself repeatedly as he supervised the crew made up of students from the Art Students' League and Otis, as well as a few who worked for the WPA. The murals merged Japanese and Chinese styles and owed much to the teachings of Stanton MacDonald-Wright, who had said the West had to stop thinking in linear patterns. Western rationalism would never be the answer. The idea was to juxtapose different colors without using traditional western techniques of perspective to create an illusion of depth.

Benji, MacDonald-Wright's most promising protégé, created his own mural on the raw brick walls of the basement. On one wall he painted the Eight Immortals, incorporating each of their symbols: the fan that Chung-li Chuan used to revive the souls of the dead; the sword that Lu Ting-pin, the scholar and recluse, used to rid the world of evil; the lotus of Ho Hsien-ku, who had eaten of the supernatural peach, become a fairy, and lived on powdered mother-of-pearl and moonbeams; the pilgrim's gourd of the beggar Immortal Li Tieh-kuai; the castanets of Ts'ao Kup-chiu; the flute of Han Hsiang-tsu; the flower basket of Lan Ts'ai ho; the bamboo instrument of the magical and often invisible Chang Kuo-lao. On another wall, Benji drew a large Buddha. On a third wall a warrior fought a dragon. The way the dragon moved in and out of the clouds, with each scale perfectly rendered, was reminiscent of MacDonald-Wright's WPA-sponsored mural in the Santa Monica Library.

Benji drew the outlines and his helpers filled them in. He was a fine colorist and the pigments glowed like jewels, but Benji was also finicky and stubborn. At the end of the day he would shout, "No, no. Not like that. Paint it out. Tomorrow we start over." The next day, Benji would once again carefully draw the outlines of the Immortals, and his helpers would try to satisfy him. No one except Tyrus had the nerve to cross Benji.

"Geez, I know the Immortals have long earlobes, but these are very long."

The next day the lobes would be drawn in even longer.

"Geez, I know the Eight Immortals have hair coming out of their nostrils and ears as a sign of longevity, but those are bushes."

In response, Benji directed his minions to paint each hair in separate, long, perfect curls.

Dragon's Den opened on February 1, 1935, to immediate acclaim. Los Angeles was still a relatively small city, and word of mouth traveled quickly. The arty crowd came to see the murals. Those who cared about food came to sample the "authentic" fare. Eddy served "family-style" meals, a concept still quite novel in America. Until the mid-1930s, Chinese restaurants were universally known as "chop suey joints," and all Chinese food was called chop suey. At Dragon's Den, a party could order an entire meal for fifty cents, seventy-five cents, or a dollar per person. The inexpensive dinner comprised soup, chow mein, Chinese peas with *char siu*, egg foo yung, fried shrimp, and rice. Prices for à la carte dishes were based on the size of the serving bowls of almond duck, sweet and sour pork, and soy-sauce chicken. These Americanized Chinese dishes—tame by today's standards—were exotic and adventurous in the thirties. (But, as did most other restaurants in Chinatown, Eddy provided a separate menu printed in Chinese that listed more authentic dishes, at more authentic prices.)

The restaurant was hot, and that brought in the Hollywood crowd. On any given night, Sydney Greenstreet and Peter Lorre could be found at a back table dining together. Already those names meant something—mystery, adventure, a walk on the seamy side of life. But it wasn't Casablanca. There was no search for a black bird. These celluloid images would come later. Walt Disney might be at another table with his entourage. Walt Disney—what an odd image *that* conjures up. But he was a man at the top of his form. So in our memories Disney must have had some other aspect to his character— not the all-American family-entertainment man, but a man who would go to Chinatown, step down into a dark basement, and treat a table of friends and colleagues to a fifty-cents-a-person family-style dinner of soup, almond duck, fried shrimp, and egg foo yung.

Between tables dotted with the well-known were others, aspiring artists who were mad about everything Chinese. To them, the See family seemed like a *force*. Dragon's Den *was* art in Los Angeles. Others—the men and women who created illusion in Hollywood—came as part of their work. There were directors, producers, cameramen, costume designers, set designers, and set decorators. Upstairs, Milton and Ticie spent the day with them as they searched for authentic pieces to use in films. At dusk, Ticie would say, "Ming, they've been here so long. Why don't you take them downstairs for a good Chinese meal?" And of course he would, because, skeptical as Ming had been, there was nothing like success, and the waiting line that wound up Marchessault and around the block onto Los Angeles Street bespoke success. This was good

news to all of the Sees, for even now everything still went into the family pot—whether it was from the store, the factory, or the restaurant. As the Depression wore on, Dragon's Den supported a total of five separate households.

To a different world the "different" came. Dragon's Den became a haven for homosexual men and women. What other place in the city would accept them the way that Eddy and Sissee and Tyrus and Benji could? Who else would take them in, treat them with joshing respect, allow the individual preference?

No one ever took a photograph of the interior of Dragon's Den—or if any were taken, they haven't survived—and only in municipal archives do photographs of the exterior even exist. They show a brick building sloping down a hill, with the characters for "Dragon's Den"—in Chinese and English—painted by Tyrus Wong along the side. But the rest—the murals, the people, the food—live only in a handful of memories tinted by nostalgia. Beyond these images of the concrete are the more ephemeral feelings imprinted on patrons of golden evenings, of love and mystery, of the conviction that they were *in the world*. In one sense, these perceptions are absolutely valid. In another, they are pure fantasy, illusions created by the camera of the mind, for just under the surface of this romantic façade a marriage threatened to fall apart.

Brown Jordan Recliner in Overgrown Grass, Los Angeles, 2015

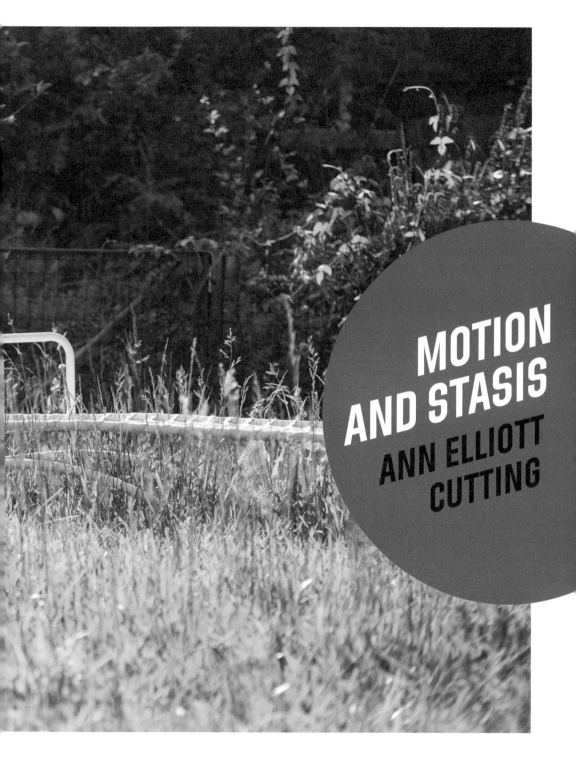

MOTION
AND STASIS

ANN ELLIOTT
CUTTING

Los Angeles is rich with people, culture, and variety. At any hour, the city is complex and fascinating. Making a photographic image in L.A. allows one to pause for a moment while the city continues to hum. It is a time to notice the juxtapositions, details, and to see the forest for the (palm) trees.

While navigating the city in daily tasks and routine journeys, I am surprised at how many new spaces I have never seen. It is endless in a good way. Days and nights are filled in this metropolis, and life here is full of stimulation. I, like other Angelenos, find myself a frequent visitor to the port area of Los Angeles and all that lies between the beaches and the mountains.

I seek to capture a lull. Just a pause with an interesting composition and some nice L.A. lighting.

—A.E.C.

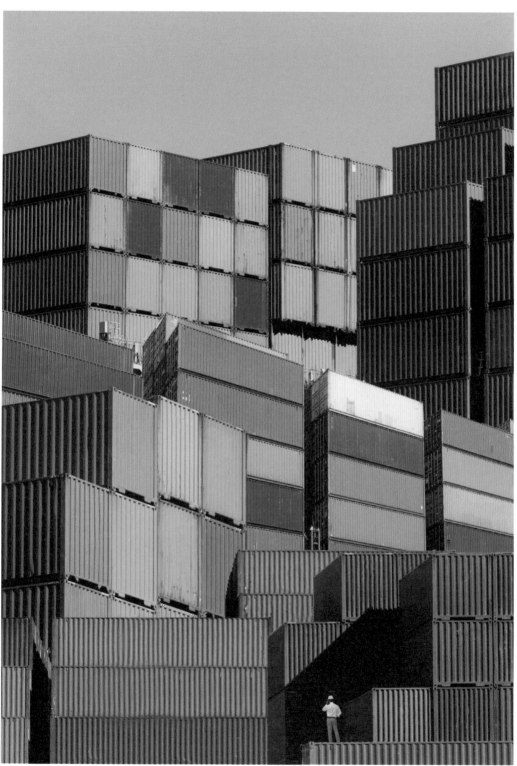

Port of L.A. Colorized Shipping Containers, San Pedro, 2018

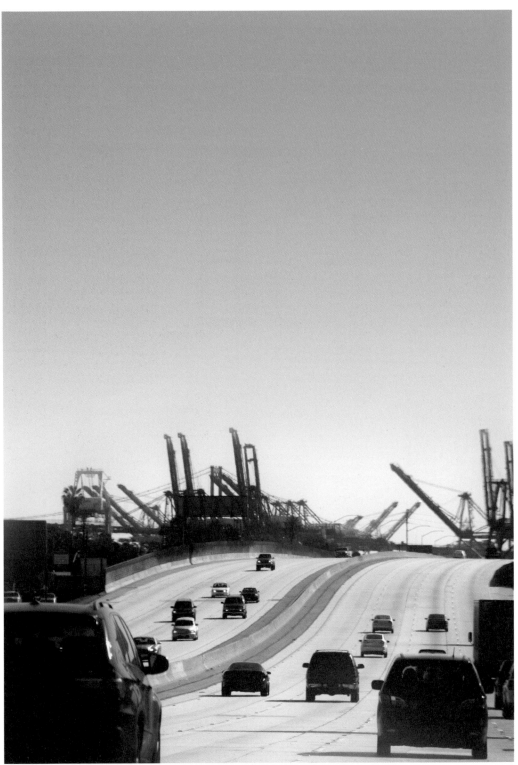

Harbor Freeway (110), San Pedro, 2015

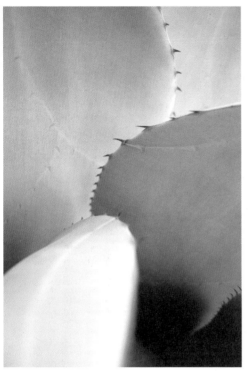

Botanical Shape, Huntington Botanical Gardens, San Marino, 2017

Parking Meter, Los Angeles, 2016

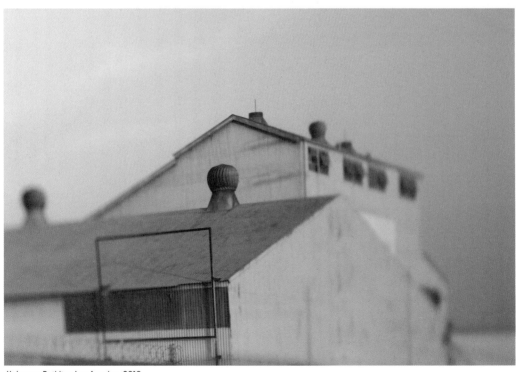

Unknown Building, Los Angeles, 2010

Neighborhood, Alley Outside My Studio Window, Pasadena, 2016

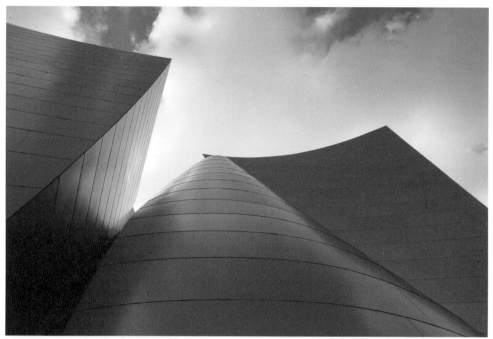

Walt Disney Concert Hall, downtown Los Angeles, 2017

Statue, Huntington Botanical Gardens, San Marino, 2017

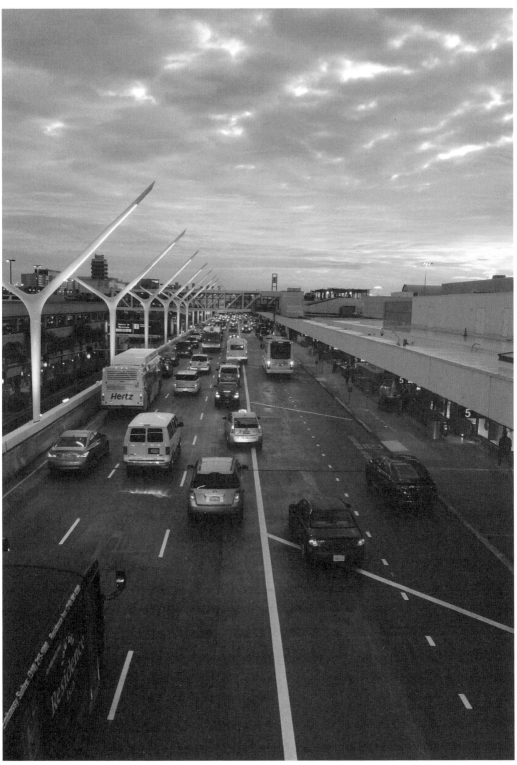

LAX Early-morning Arrivals, Los Angeles, 2015

Twin Palms with Sky, Pasadena, 2016

At the turn of the twenty-first century, valuable books, recordings, articles, and oral histories about the heyday of Central Avenue became available, but they (necessarily) treated the famous street and its stories of nightlife, jazz, and a vibrant Black community as lost treasures. Emphasis was on the preservation of the facts and spirit of the music legacy—who played what, where, and when; which L.A. high school music programs cradled which jazz geniuses. In his 2006 California Book Award–winning *The Great Black Way*, R.J. Smith brings a journalist's investigative sensibility to the subject, creating an almost-current-events perspective to this vivid history. Smith expands on certain musical milestones in the Central Avenue timeline, pairing those stories with pertinent local political context. In this selection, Smith describes an often forgotten but significant chapter in civil rights history by interweaving the stories of a lawyer involved in challenging housing restrictions and a musician riding the wave of a sensational pop-music hit.

SET TO MUSIC 1
CENTRAL AVENUE

THE GREAT BLACK WAY
L.A. IN THE 1940S AND THE LOST AFRICAN-AMERICAN RENAISSANCE

R.J. SMITH

FROM "CHILDREN OF CHAOS"

LOREN MILLER, ATTORNEY, NEWSPAPER EDITOR, FAMILY

man, didn't have the time or the inclination to hang out at a place like Brother's [a Central Avenue nightspot]. Miller was a public figure, instantly recognizable in the street and downtown. Yet he shared at least one quality with people like Korla Pandit and Charles Brown [musicians with pasts]. It's not that he had secrets, per se, just that he had done things that others, perhaps, had not. Loren Miller was a figure of great experience, and he wore that knowledge lightly upon his face. The experience, along with a suspiciously placid smile, would serve him well as he faced the fevered events of 1948.

Loren Miller loved being a newspaperman, but it was his legal work that put food on the table. With a civil rights practice representing people of limited resources, Miller didn't even put that much food on the table.... Miller built up a practice in the 1940s that became widely known for a particular specialty: the defense of those prosecuted for violating housing covenants. This expertise was just one part of his practice, but it was his work fighting housing restrictions that made him the most important civil rights figure in Los Angeles. Journalist and lawyer Carey McWilliams labeled Miller a likely candidate for the Supreme Court. Today he is more or less forgotten,

his greatest victories taken for granted, the sum of his accomplishment barely a footnote in the capital of amnesia.

The construction of the black ghetto in Los Angeles had been achieved through a system of private agreements among property owners, pledges that homes would not be sold to "non-Caucasians" were written into deeds, and courts declared them legally binding. With the influx of black workers during the war years, these agreements were similarly on the upswing throughout Southern California. They fortified the walled city that was Bronzeville and the Central Avenue corridor, keeping those within from easily moving elsewhere.

 Housing restrictions may have been used in many parts of the country, and they were notably popular in the North after World War I as Negroes moved en masse from the South. But they were all but invented, and then refined, in Southern California. The first court battle over them occurred in San Diego in 1892, when a judge ruled that an attempt to close a Chinese laundry was illegal because it violated the equal protection clause of the Fourteenth Amendment to the U.S. Constitution. Illegal such moves might have been, but in 1919 in a case involving a black Los Angeles police officer who had bought a home in a white neighborhood, a California judge decided Californians could live with such agreements, too. By then, developers were carving whole subdivisions of the city out of miles of dusty lowlands. Subdivisions were being drafted in real estate offices, in a process that provided a fine opportunity to give three-dimensional shape to one's notion of the ideal community. Vast empty spaces had to be filled and developers thought big, imagining themselves as social engineers. Such thinking went unchallenged for decades....

From the start subdivisions routinely had language written into individual deeds declaring which people could live there and which could not. In already established neighborhoods, homeowners were adding discriminatory language to their property deeds, ensuring a single address stayed white. The more effective way to influence a neighborhood's complexion, however, was through mutual pacts made by people of an entire block or development who had formed a homeowners association. Like-minded folks could agree among themselves who should live in the area, and protect their vision by signing contracts declaring to whom they would sell their home. Should the agreement be broken, the community association took the violator to court, where precedent was on its side.

Los Angeles was built in enormous tracts, but it was sold to the rest of the country one house at a time—a legion of salesmen, barkers, hype merchants, and pitch men promoted Southern California to whites and blacks alike as the place where a family could get a fresh start in a sunny, citrus-scented paradise. Homeownership underpinned what it meant to be an Angeleno; denial of homeownership amounted to a revocation of citizenship rights. In Los Angeles, a sprawling metropolis dependent on the automobile, mobility became essential to existence. Access to the area's expanse equaled liberty in exceptionally brutal ways in Southern California; the shutting off of access was felt in exceedingly personal ways. The more of the map that was rendered off-limits to non-Caucasians, the more non-Caucasians were rendered invisible. It was Miller's genius to appreciate the extent to which in Los Angeles, racism was manifest not through laws but through *geography*.

Talking with mock pride at a Chicago housing conference in 1946, he touted the West Coast's accomplishment:

> Speaking as a Californian—and necessarily boasting, for who can mention California, especially Southern California, without boasting?—I am certain that there are Californians who would want me to remind all of you that, due no doubt to our salubrious climate, my state has produced racial restrictive covenants as far superior, if that is the word, to the ordinary run-of-mine racial restrictive covenants as our climate is to the climate of other and less fortunate sections of the nation.

Miller knew better than anyone what Los Angeles could contribute to the national fight for civil rights. Having studied the legal history of covenants and knowing that by the end of the war his home state had more of them than any other state in the country, Miller plotted an assault that began as a block-by-block fight and ended in the Supreme Court.

Among those who knew Miller best, the only surprise about his commitment was how it revealed itself in the courtroom. For law was never a huge part of Miller's sense of himself. He much preferred being a journalist and had struggled to write a novel for years.

"He didn't really like going to court," said Stanley Malone, a law partner. "The whole court scene—the deference to the judge, the courtesy to the other side—he saw as a shortcoming to practicing law. Especially when you are superior in your thinking."

"Tall, thin, slightly sardonic Loren Miller," the _Tribune_ called him.... That sardonic streak helped him cope with the whimsy of Los Angeles segregation. Although ownership of property was legal everywhere, black _habitation_ of a restricted home was illegal. Thus arose a genre of sarcastic headlines in the black press like the one declaring "Negro Wins Fight to Live in Own Home"; thus rulings like the 1946 edict in which a judge declared a white woman could live in her house, but her black husband would have to go.

An Urban League official estimated that by the mid-1940s, some 80 percent of the city was blanketed by restrictions. "We [are] well on our way toward the creation of little islands of super-paradise in that Paradise of the Pacific," Miller joked. "Communities in which none could dwell but blond-haired, blue-eyed Aryans, certified 99.44 percent pure for at least seven generations, all of them five feet 10 ⅞ inches tall, addicts of _Little Orphan Annie_, and lifetime subscribers to, perhaps, _The Cross and The Flag_."

The real estate interests kept pace with the wartime migration, their efforts to extend a cloak of restrictions across the city turning into something ardent and comic. In Culver City, southwest of Hollywood, citizens congregated at city hall under a banner reading "God Bless America: Life, Liberty, and Justice for All" to discuss keeping blacks out. They deputized air raid wardens—the officials watching vigilantly for foreign invaders—to go door-to-door with petitions targeting homegrown invaders. The head of civilian defense urged volunteers to visit areas where deed restrictions had lapsed or were about to and compel homeowners to update their covenants. There was a war on; this was part of the home front struggle. [. . .]

Loren Miller grew up along various borders of identity, region, and race. He was born in 1904 in Pender, Nebraska, a small town on the Omaha and Winnebago Indian reservation. His father was born a slave in Kansas and after the Civil War had left Kansas for the North. Miller's mother was a white schoolteacher; she was unable to teach in Pender because of the mixed marriage, and the family moved to a farm outside of town. When Miller was a teenager, the family moved to Kansas. At sixteen Miller entered the University of Kansas in Lawrence, but later returned home to help his family after his father died. When he went back to college, it was to Howard University in Washington, D.C., where he majored in journalism. He began writing opinionated essays that attracted the attention of writer Langston Hughes, one of the anchoring voices of the Harlem Renaissance; the two became close friends for the rest of their days. Hughes brought Miller onto the staff of

The Crisis, the esteemed journal published by the NAACP and edited by W.E.B. Du Bois, who became a friend and mentor to Miller. He also wrote for the *American Mercury, The Nation*, and other publications.

Chafing at the Dixie-style race relations of the nation's capital, Miller moved to New York, where Hughes lived. Ultimately, he didn't like New York all that much more than Washington: imbued with the Harlem Renaissance but not impressed with it, Miller returned to Kansas, earning a law degree at Washburn College of Law in Topeka. He set up practice in 1929, a big fish in a Kansas swimming hole. By then, his mother and siblings had left the state for Los Angeles; after a family funeral brought him there, he saw an opportunity and plotted an escape from Topeka. Miller talked his cousin, Leon Washington, into going with him, and together they were hired by the *California Eagle*, Miller as a writer and Washington as a writer and advertising salesman.

The fledgling journalist kept in touch with his East Coast chums, and when Louise Thompson, a political activist and denizen of the literary salons, asked him to join a group of Negro actors and artists traveling to Russia, Miller jumped at the chance. He accompanied Hughes, Thompson, and nineteen others sailing by steamship in June 1932 on a trip paid for by the Communist International; the plan was to make a movie in Russia about the condition of blacks in the American South.... The trip became an international news story and a scandal at home. Upon Miller's return and for the rest of his life, the adventure would haunt him every time a panel convened in search of Communists in high places. Though he was never a member of the party, he straightforwardly acknowledged his attachment to the cause early on. Those early writings in *The Crisis* and elsewhere were full of revolutionary zeal; they, too, would follow him around for the rest of his life. [. . .]

[By] 1939 he was on the outs with the party and championing individualism over revolution. He had married a glamorous L.A. sociologist with lefty connections of her own, and with his cousin Leon Washington had started a newspaper, the liberal *Los Angeles Sentinel*. Together they masterminded the *Sentinel*'s successful "Don't Buy Where You Can't Work" campaign, organizing picket lines outside white businesses. Miller had matured, or perhaps he had simply begun to accept his lot as a practitioner of the law. He let Washington march on the line and get arrested. Miller would be the one to bail his cousin out, defend him in court, and then compose the editorial the following week.

His first restrictive covenant case came in 1939; as of 1945 he had handled about fifteen, but by 1947 he was at around 100. The surge showed not just that housing restrictions were on the rise, but that in key ways Negro rights were in retreat.

Soon the police department began drawing lines of their own. An aspiring actress named Elizabeth Short was found murdered on January 15, 1947. Posthumously dubbed the "Black Dahlia" in the press for the clothing she wore and the color of her hair, rumors circulated that Short had been seen drinking in the Negro part of town. A media storm followed the gruesome discovery of her body and the police launched a series of raids on Central Avenue clubs, sending a signal that places where the races congregated—particularly black men and white women—were off-limits. Negro nightclubs were, in the words of assistant police chief Joseph Reed, "breeding places where crimes are planned and carried out. We are going to purify the city of Los Angeles.

"It is the women who frequent these places that are cast along the Black Dahlia lines and all too frequently end up in the same way."

Seizing on the Black Dahlia panic, the police department set up roadblocks around Negro and Latino neighborhoods. They stopped cars by the hundreds and lined drivers up against walls, subjecting them to humiliating searches. It was one more sign of lines hardening.

Then, a few months later, something gave way. For years Miller's strategy in fighting restrictions was to argue that their proponents were in violation of the Fourteenth Amendment, specifically the clause establishing the right to due process and equal protection under the law. He had stuck to this tactic even when it failed him in court; a more effective strategy had been to show that a neighborhood had substantially changed since the restrictive language had been written—that is, to show a Negro was moving into a neighborhood where others already lived. But Miller held on to the constitutional argument, convinced that it struck at the heart of covenants everywhere.

He was a member of the national NAACP brain trust that formulated the organization's long-term legal strategy. Along with Thurgood Marshall, Charles Houston, William Hastie, and a handful of others, Miller had been combing the dockets for promising cases that could be bundled together into a petition to the U.S. Supreme Court. Late in 1947 the Supreme Court agreed to hear their case, which included four regional appeals—one in St. Louis, one in Detroit, and two in Washington, D.C. The case was *Shelley v.*

Kraemer, and Miller would be one of the attorneys arguing before the court in May 1948. Here was a chance to fight institutional racism across the country, not to mention a chance to rip up the map of Los Angeles. That summer Miller headed to his old stomping grounds of Washington, D.C.

Meanwhile, back on Central Avenue, [musician and band leader] Jack McVea was also starting to get somewhere. He had just recorded a song called "Open the Door, Richard!" and when it hit the streets in late 1946—the same spring that the police's new "crime crushers" barricades were brought out—McVea scarcely knew what he had. He'd find out soon.

A saxophonist from a musical family—his father Isaac led McVea's Howdy Entertainers and had a regular slot on KNX's *The Optimistic Do-Nut* show in the late 1920s—the son fell naturally into the musician's life. In the 1940s he assembled a small band of his own in which he played tenor sax.

McVea got the inspiration for his little tune one night in Oregon. His five-piece combo was touring the West Coast, playing a blend of small-group swing and R&B. In Oregon they fell into a groove and McVea started talking over it, performing an old comedy routine he knew by heart. It hardly seemed special; he was only putting music to words lots of people had heard before, just clowning. That was about as deep as McVea's band got, in their zoot suits and sombreros and pith helmets. They danced onstage, screaming and mugging and barrelhousing. And here was a number perfect for goodtime hats and people-pleasing stagecraft, a riff that sent the crowd home happy.

The band was back in Los Angeles, parked in a Hollywood studio and flat out of inspiration as a recording session for the local Black & White label rolled on. Producer Ralph Bass later claimed recording "Open the Door, Richard!" was his idea. "I was doing some blues with [McVea]. I got bored to death because everything sounded alike so I suggested that he do 'Richard,' which I had seen him do live."

Others said it was McVea's decision to record "Richard." However it happened, "Open the Door, Richard!" changed all kinds of history, and its story illustrates how immensely and unpredictably a song can matter. "Richard" mocks the notion that what means the most is what has the most to say. "Richard" seemed to be saying very little, but it spoke loquaciously to the moment Los Angeles and Loren Miller found themselves tangled up in.

There really was a figure named Richard, living in music and words long before McVea caught up with him. Pigmeat Markham, the star of the Lincoln Theater, knew him earlier than most. Markham performed with a

minstrel show called the Florida Blossoms in the early 1920s and there met his mentor and inspiration, Bob Russell. A producer and writer with many stage shows to his name, Russell had a career in minstrelsy dating back to the Civil War. Some thought Markham had come up with the Richard routine, since he'd performed it for decades. Others thought a comic peer who was a little older than Markham named Dusty Fletcher was the creator. But the truth, Markham writes in his autobiography, is "that song was written by my old friend Bob Russell, and he wrote it for a long-ago show called *Mr. Rareback* in which John Mason sang the song." That's as close as we can get to the origins of "Richard."

From Russell on down, "Richard" passed from one variety show to the next. Dusty Fletcher did as much as anyone to make "Richard" familiar to black audiences. In Fletcher's version of "Richard," he played a tenement bon vivant at sunrise, staggering home only to find the door to his apartment locked. He hollers up to his roommate Richard to let him in, but Richard seems otherwise occupied; Fletcher can hear the heavy breathing coming from inside. "I know he must be in there because I've got on the suit," Fletcher told his audience. Like a blues guitar lick shot out of the Mississippi Delta, like a slang term for the white man fresh out of New Orleans, Richard's weird fame was absorbed in Negro neighborhoods around the country as communal property.

Among those who probably heard Markham do "Richard" at the Lincoln Theater was Jack McVea. His career was on the upswing, for he'd played on the Lionel Hampton Band's landmark 1942 "Flying Home" recording and recorded with T-Bone Walker, Slim Gaillard, and Charlie Parker.

He formed his own group, one based on the swank, air-cushioned R&B of Louis Jordan's Tympani Five. They set music to the version of "Richard" that McVea pulled out of his hat that night in Oregon. "That simple melody just came to me," he told an interviewer. The easygoing banter of McVea and drummer Rabon Tarrant, the bebop shadings the pianist throws in, the ghetto banter they cooked up, all of it slayed them alive, and then McVea put it on a record. Released late in 1946, "Open the Door, Richard!" quickly became a local jukebox favorite. Later, after the song made him a national star, McVea told me the biggest thrill of all was overhearing a little old lady tell a local streetcar conductor, "Open the door, Richard." [. . .]

The tune first hit on the Avenue and then fanned out to Negro neighborhoods coast to coast. By early 1947, demand was outstripping the label's supply. The February 15 *Los Angeles Sentinel* announced that Black & White was sending "one of the largest single order shipments of records ever

carried by air"—10,000 copies airlifted to New York City alone—"in a C-54, which has the largest plane door ever constructed."

An R&B craze had launched; numerous black artists quickly cut cover-and-answer records, many of which also climbed the "race" music charts. Besides McVea's liftoff (number 3), there were versions by Count Basie (number 1—the biggest hit he ever had), the Three Flames (number 1), the Charioteers (number 6). Dusty Fletcher cashed in (number 3), and McVea's mentor Louis Jordan himself was moved to cover the tune (number 6).

But if by February "Richard" was a smash in the Negro community, the praise was far from universal. A shouting match broke out in the letters sections of Negro newspapers, as "Richard" became an unwitting lightning rod for tensions between rural and urban, old and young, zoot suits and swallowtails. McVea was scorned as a product of Hollywood, his dap band flossy and glib compared with old-school Southerner Dusty Fletcher. The battle over "Richard" was about style, and whether one responded to Fletcher's ragged but right suit and top hat or McVea's draped shape said a lot about who one was. Meanwhile, pillars of society viewed *any* rendition of' "Richard" as an embarrassment, and one critic acutely summed up his minstrelsy roots as "Uncle Tom-y." They sensed in the frivolity of the McVea band everything that was holding back the race.

Perhaps as well critics dreaded the young listeners who wore zoot suits and reflected their energy back on the band. These fans embraced "Richard" and gave him meanings McVea had never intended, any more than he intended to be a symbol of backwardness. To at least some Negro listeners, "Richard" was a barely secret call for justice's doors to spring open. In 1947 students from seven Georgia colleges marched to the state capital demanding the resignation of segregationist governor Herman Talmadge, carrying banners reading, "Open the Door, Herman."

On the road, McVea found himself thrust into the role of agitator. In May, Indianapolis mayor Robert H. Tyndall nixed McVea's appearance at a Teen-Agers Frolic, declaring there would be no mixed dances in town. The chief of police refused to issue a permit; McVea, his manager, and the CIO sponsors of the show researched local law and found a loophole allowing dances without permits if they were classified as private club events. The dance went on, and "Bandleader McVea expressed himself to the hundreds of teen-agers gathered by working the four-hour dance period without one breathing spell," cheered the *Chicago Defender*.

On Central Avenue, of course, the cramped living conditions and squalor gleaned from the song were flourishing. "Richard" became a mirror in which a ghetto community could view itself and gave that population a voice in the creation of popular culture.

Across the country, Richard became a fair-housing messenger. A March 1947 story in New York's *Amsterdam News* reported on a sermon given by Reverend Horton A. White, pastor of Plymouth Congregational Church in Detroit. The sermon was titled "Open the Door, Richard": "This ditty which is sweeping the country on stage, air, and records was made to have deep seated meanings by Rev. White as it dealt with restrictive covenants in this community," reported the paper.

> Rev. White stressed the fact that...the doors of equal opportunity for better housing for Negroes must be opened so that he can walk boldly into any house in any neighborhood where he is capable of purchasing or renting. In this case Richard (the courts) is not asleep but is prejudiced and stubborn but sooner or later will be forced to open the door when restrictive covenants are definitely broken.

Other audiences tuned in; white people met Richard. They were hearing the same song, but in an entirely different way. By March 1947, "Open the Door, Richard" had become a jovial salute on national radio shows, a catchphrase uttered by Jack Benny, Fred Allen, and Phil Harris. Jimmy Durante and Burl Ives recorded versions, as did the milk-and-cookies harmony group the Pied Pipers....

"Richard" became a marketing craze, perhaps the first one of the postwar era. Dime stores sold Richard hats, dungarees, handkerchiefs, shirts, bracelets, and other memorabilia. He was used to sell Ruppert Ale, Franklin Simon perfumes, and Best Yet hair attachments. Bugs Bunny riffed on the song in the cartoon "High Diving Hare."...

In the *Los Angeles Sentinel*, in an editorial written by Loren Miller, the call went out for black political representation at City Hall. "We are glad to see Negroes knocking at the door and we hope that they keep on pounding until our sleeping city fathers get up and open that door," he said. His headline made it clear: "Open the Door, Richard."

In the summer of 1948, Miller broke the door down. He and three other NAACP lawyers argued the unconstitutionality of restrictive covenants

before a truncated version of the Supreme Court—three justices had recused themselves from the debate, and though nobody said for sure, the word was that each owned property with deed restrictions. That May the justices, following Miller's lead and citing the equal protection clause of the Fourteenth Amendment, ruled that restrictive covenants were unenforceable by the courts. Though they didn't say such agreements were per se illegal, individuals had to police them for themselves.

The ruling dealt a huge blow to housing segregation and was felt instantly on Central Avenue. Almost from that day forth, blacks began moving out of the old enclave, and a massive push westward to Baldwin Hills and Culver City, south to once lily-white Compton, north to the San Fernando Valley, was on. Housing stock had disintegrated along the Avenue, and if Bronzeville was the worst of it, the rest of the avenue was also full of overcrowded, substandard homes. *Shelley v. Kraemer* led many to start packing their bags.[. . .]

When geographical barriers lifted, it meant the irreversible lifting of other barriers. Los Angeles had never codified its segregation in its body of laws; with Jim Crow nesting so neatly into the growth of the city through restrictions on huge tract developments and through the regulations of neighborhood organizations, there was no room for messy arguments in public about the need for legislation.

Restrictions lingered until in a 1953 case, *Barrows v. Jackson*, the Supreme Court extended the implications of *Shelley* and effectively declared them null. In a story Thurgood Marshall liked to tell, arguments on *Barrows* had begun in the afternoon and then were held over for a second day. That night, Justice Felix Frankfurter told retired Justice Owen Josephus Roberts that he really ought to come down to the court tomorrow, because "some young Negro lawyer is giving the chief justice hell." It was Loren Miller Frankfurter was referring to.

True enough, the real estate lobby in Southern California agitated for a constitutional amendment to preserve restrictions. True enough, mortgage loan lenders and property owners' organizations found ways to segregate for years after *Shelley* and *Barrows* were law. As Los Angeles integrated, there would be bricks through windows and burning crosses on front lawns, and dynamite would explode....

Jim Crow took a whipping in L.A. with the defeat of the covenants' legal foundation. And because of Miller's work, Central Avenue started melting away. The legal strategy honed in the case—the call for equal protection

under the law as declared by the Fourteenth Amendment, the use of an array of sociological data to argue the damage done to Negro Americans by this wrong—would hold sway in civil rights circles for years to come. Indeed, as strategy and symbol, *Shelley* laid the groundwork for the victory a decade later in *Brown v. Board of Education of Topeka*. "It is obvious," said attorney Thurgood Marshall after *Shelley*, "that no greater blow to date has been made against the pattern of segregation existing within the United States."

Chinatown, Los Angeles, 2010

PHOTO BY ANN ELLIOTT CUTTING

Linking several decades of the city's cultural and political history, Harry Hay arrived in Los Angeles at age seven, worked in his youth as an actor, stunt rider, and dialogue coach, and was a union organizer in the 1930s and '40s. By the time he died in 2002, he was a leader of the worldwide network of Radical Faeries and a revered elder of the LGBTQ rights movement. His friends included icons John Cage and Will Geer; as a teacher of music appreciation at the California Labor College, he spread Woody Guthrie's songs (by playing lacquered aluminum discs to his classes) when Guthrie was discovering his agitator's voice while living in L.A. As Stuart Timmons details in his biography, *The Trouble with Harry Hay*, Hay was also co-founder, with designer Rudi Gernreich and others, of one of the nation's first gay-rights organizations. Timmons, himself an activist, was a remarkably apt biographer of Hay, capturing his subject's counterculture spirit and a time when L.A.'s beaches were mapped by secret demography.

STAG LINE
THE
PROSPECTUS

THE TROUBLE WITH HARRY HAY

STUART TIMMONS

"MATTACHINE"

AFTER TWO YEARS OF DEAD-END PLEADING,

Harry found support from an unexpected turn of events—he fell in love.
His relationship with the young Rudi Gernreich changed everything. It
brought an end to Harry's marriage, terminated his membership in the
[Communist] Party, and, most important, lifted his deep psychic distress.
The day he met Gernreich, he often said, they created a "society of two" that
became the Mattachine.

Gernreich's friends recall him as a dazzling combination of intelligence,
looks, and élan. "Rudi was very charismatic and had a presence that could
fill a room," said his friend Martin Block. Harry recalled of the lover he
never completely relinquished: "Rudi had a gentle command of everything.
He was bright, witty, and had the most subtle sense of humor. He had come
from Vienna as a sixteen-year-old refugee in 1938 but could make double
entendres in English without batting an eye. Everything he touched had a
little something extra—that spirit was in his dancing, his speaking voice,
the clothes he designed. Even the way he dressed himself every day had
that signature."

For years, Gernreich was Mattachine's mystery man. In accordance with

the Mattachine oath of secrecy, Harry never revealed his co-founder's identity until after Gernreich's death from lung cancer in 1985. The necessity for this was dramatically underscored when Gernreich achieved world fame as a designer through the sixties and seventies with such fashion breakthroughs as his topless bathing suit, unisex look, and shaved heads. Harry referred to him by his initials or as "X" in interviews in the 1970s, but since his death, Harry has frequently credited Rudi Gernreich with cutting the pattern for the gay movement. Gernreich never commented publicly on Mattachine or the gay-rights movement, explaining privately that the rules of the fashion industry prohibited his taking a public stand. His public "coming out" was posthumous: The American Civil Liberties Union announced that the estate of Gernreich, along with his surviving life partner, Dr. Oreste Pucciani, had endowed a charitable trust to provide for litigation and education in the area of lesbian and gay rights.

Harry met this remarkable new friend on Saturday, July 8, 1950, at Lester Horton's Dance Theatre on Melrose Avenue. The company had a markedly progressive membership; Eleanor Brooks, its prima ballerina for a time, was the sister of Miriam Sherman, Harry's C.P. section organizer. As Harry sat in the audience that afternoon observing seven-year-old Hannah [his daughter], he became aware of being watched. Harry recognized the observer, Gernreich, from several Horton Troupe productions. Rudi had recently quit dancing to pursue a fashion career; some of his first designs, in fact, were costumes for Horton's company.

As the children practiced, the two men found themselves sitting near one another and chatting intensely, mostly about the war that had been declared in Korea less than two weeks before. Gernreich ran in Leftist circles and agreed with Harry's skepticism of the official justification for the war. But politics aside, the handsome Viennese set all Harry's romantic bells to ringing. After nearly a decade of denying his emotions, he was overcome. "Almost from the moment of our meeting," he wrote after Gernreich's death, "we were in love with each other and with each other's ideas." They made a date for dinner the following Monday.

The 28-year-old Gernreich had the gracefully developed body of a dancer and large, dark, expressive eyes. He wore a standard uniform of black pants and turtlenecks, which made his pale, clear complexion stand out, Harry thought, like a cameo. Thunderstruck, Harry spent the rest of that Saturday wondering "how such a beautiful creature had wandered into my life." But he

also worried. "What were we going to have in common? I was determined we were going to have something in common and it was going to be profound." He remembered too well his relationships with arty boys had failed because of political differences. "At age thirty-nine," he said, "I wasn't going to repeat those mistakes." Over the weekend, he feverishly revised his prospectus calling the "Androgynous Minority" to unite. This is the version that survives, complete with a few typographical errors, including the misdate of July 7 instead of the actual date, July 9. It was Harry's third draft since the Bachelors for Wallace prospectus, and it had grown to six typed pages.

When Monday came, he took Rudi to the Chuckwagon, a new restaurant just west of the Sunset Strip. He passed the prospectus over the table. Rudi was intrigued. "It's the most dangerous thing I've ever seen, and I'm with you one hundred percent," Hay recalled him responding. While he encouraged Harry's undertaking, Gernreich counseled extreme caution and discretion, both for the sake of individuals and for the stability and potential of such an American movement. He explained that before leaving Europe, he had been aware of the homosexual movement led by Magnus Hirschfeld, whose publicly known Institute for Sexual Research had been easily smashed by the Nazis: Its records sent homosexuals to death camps. They talked about many aspects of "our kind of love." The vastness of the subject and the prospect of an organization excited both men. "We sat there, by law unable even to hold hands, but looking warmly at one another, a sort of glowing through tears across the table."

After the restaurant closed, they parked on a hill overlooking the glittering nighttime cityscape and talked between kisses about their various interests, but mostly about this new goal of organizing. The affair that developed was emotionally intense for both. Before meeting Harry, Gernreich's relationships had rarely lasted more than a few months.

Since Gernreich lived with his mother and aunt, and neither Rudi nor Harry had money for a hotel room, the lovers had to cast about for privacy. Bill Lewis, the gay typist at Leahy's, offered the afternoon use of his rented room in a clocktower of the First Presbyterian Church, but the loud bells clanging on the quarter hour disturbed their secluded trysts. Bill Alexander, then alternating between jobs in Los Angeles and New York, offered the use of his apartment at 313 Alta Vista Drive in Hollywood. They met there twice a week for a year. Harry still lived with his family and never told Anita of his new relationship. He did buy one of Rudi's samples for her, a simply cut

dress of an oversize houndstooth check. "It was one of those dresses she wore forever because it never went out of style," remembered her daughter Kate. Rudi painted Easter eggs for the girls that spring, but they never met their daddy's talented friend.

Harry explained to Rudi the frustrations he had experienced since writing the first prospectus the night of the beer bust. After the rejection of the initial plan for meetings, he had devised a façade: He would announce a public meeting to "objectively" discuss the *Kinsey Report*, a cautious and security-minded approach to organizing. But even with such a buffer, he found himself caught in the maddening impasse of paralyzed homosexuals and noncommittal sponsors. "I had talked to hundreds of people between Bachelors for Wallace and Mattachine, and people on both sides were afraid to take the first step. It was like being told you had to have a harp to get into heaven and that you had to go to heaven to get a harp." So the organization remained unborn.

Cautious but enthusiastic, the well-networked Gernreich asked for sixty copies of Harry's treatise. "Rudi immediately had a whole program of activities we might undertake—but with more potentially viable people," Harry noted. The sociable Gernreich had already come to know many such individuals. In the film industry, he had worked as a sketch artist for Edith Head, and around the studios the handsome young designer had been befriended by such celebrities as Marlene Dietrich and Dorothy Dandridge, who were charmed by his gentle glamour. Dancing with Horton set him at the center of L.A.'s most socially conscious audiences and avant-garde artists. He took Harry to various social events and introduced him to "the bright young people." To some of these he showed the daring proposal.

Gernreich provided a steady supply of high-end contacts, including several prominent film industry people, such as MGM director George Cukor. All such discussions, of course, were marked with the same careful discretion Rudi had demanded the night they first talked. "Since we would both decide whether or not to approach somebody," Harry recalled, "Rudi would show me a photo or mention a first name to get my okay. Then, when they said no, as they usually did, he'd sternly ask me to forget he'd mentioned them."

Within a month of their meeting, the two set out on a field trip to drum up a discussion group on homosexuality. As an icebreaker, they armed themselves with copies of the Stockholm Peace Petition, a Leftist initiative to

recall the early troops that had been sent to Korea. With his gay agenda in mind, Harry took the petitions to a strategic spot. "We set about discovering new adherents on the two slices of beach Gays had quietly made their own," he wrote later. "The section of beach below the Palisades just west of Marion Davies's huge waterfront estate, and that slice of Malibu between the pier and the spit—which would be taken over by the surfers in the 1960s."

Nearly 500 sunbathers signed the petition, and while chatting, Hay and Gernreich asked each if he or she would be interested in attending a discussion on new findings about social deviancy. Not one was: "They were willing enough to designate themselves Peaceniks by signing our petitions in the teeth of the Korean War and its accompanying patriot-mongering...but were *not* willing to commit themselves to participating in easily disguised semipublic forums, oh-so-diffidently fingering the newly published *Kinsey Report*." Altogether, the canvassing only repeated the disappointment Harry had gone through during the previous two years. All he managed to glean was a mailing list of extremely tentative supporters.

Even if the beachgoers had eagerly joined up, however, the roster would have fallen far short of the solid organization and "movement" Harry envisioned. Rudi counseled perseverance. By November, after more unproductive weeks of outreach, Rudi proposed that Harry take a chance on Bob Hull, a man who had come to his music classes. Very blond, small, and boyishly handsome, he was one of those who had repeated the course often. Harry thought Hull was homosexual, but he was not sure he would join a homosexual organization. He nervously gave Hull a copy of the prospectus at the next Thursday evening class. Chuck Rowland, who lived with Hull, recalled how that night "Bob came home and told me about this delightful and brilliant teacher who had approached him about this."

On November 11, 1950, late autumn's strong winds blew up Cove Avenue. Around noon, Bob Hull called Harry and asked if he and a couple of friends could come over to discuss the paper he had received two days earlier. He gave no indication of his reaction but said he'd be over at about three o'clock. Anita and the girls were away that day, so Harry called Rudi over and together they waited pensively outside to steer the visitors to a quiet spot on the oak-studded hillside overlooking Silver Lake. A thrill broke over Harry when he saw Rowland "running up the hill, waving the thing like a flag, saying, 'We could have written this ourselves! When do we get started?'" Rowland's later recollection was similar. "We were enchanted with it. I did say, 'My God, I

could have written this myself.' I can't remember actually waving the thing in the air and running up that hill with it, but I might have." The five sat on the hill overlooking the restless water that windy Armistice Day, talking and basking in each other's excitement. "We sat there," Hay wrote, "with fire in our eyes and far away dreams, *being* Gays."

As a result of that fateful meeting, Robert Hull and Charles Dennison Rowland became two founding members of the Mattachine Society. They had become lovers in 1940 in Minnesota; in 1950, they were best friends who shared a house in Norwalk, near Los Angeles. Rowland was a thoughtful, cordial man with glasses, a crew cut, and tattoos thickly covering his chest and arms. He held a production-control job similar to Hay's in a furniture factory downtown, but his real interest was in theater. Hull was also culturally inclined but had given up an unsteady living as a pianist for a job as a chemist. Hull's large eyes and narrow face prompted Harry to compare his looks to those of the boy Tutankhamen.

Though Rowland and Hull were roommates and best friends, they had other lovers, and Hull was having an affair with a man named Dale Jennings that winter. They had shown Jennings the prospectus and brought him along. Opinionated, intelligent, and aggressively virile, Jennings had worked as a carnival roustabout and was developing a career as a writer and publicist. He was highly sensitive, and in spite of his curmudgeonly persona, he could write with clarity and slashing wit. In fact, he wrote for the homophile press under a broad spectrum of names, including one as a lesbian. Though Jennings was not a Party member, Harry knew his sister and their mother, "Ma Jennings," from Party circles of the thirties, and Hay and Rowland both regarded Dale Jennings as "one hell of a fellow traveler."

Both Hull and Rowland had been Party members. Only a few years younger than Hay, they had been caught up in the ferment of the thirties; by the late forties, Rowland was heading an organization called American Youth for Democracy, which, he explained, "wasn't officially Communist, but it was." Neither Hull nor Rowland had encountered trouble with the Party because of their homosexuality. "All the kids I worked with in A.Y.D. knew I was gay," Rowland said. "It was not an issue you discussed, but they knew. Leaders of the Party in Minnesota knew. But I don't recall the issue arising in the two years I was active. I didn't even discuss it with Bob or another gay friend who was in the Party."

Harry called Rowland "the great organizer." Less extroverted than Harry

but just as learned and determined, he shared much of Hay's outlook and organizing know-how; the other Mattachine founders described them as an effective team. (Rowland stayed active in the gay movement for many years and eventually founded Celebration Theater in 1982, still the only openly gay theater in Los Angeles.) Jennings, never shy about confrontation, served as a counterweight to Harry's forceful nature. Hull easily followed their flights of strategic theory and was able to translate that political language for others, a talent that earned him the nickname, "Viceroy of Mattachine."

The idea of a homosexual organization was not completely unknown, but in the America of 1950, it seemed like a new and dangerous invention. Role models were nonexistent; the often-cited conspiracy of silence regarding homosexuality was overwhelmingly effective. The Chicago Society for Human Rights, an organization for homosexuals, had been started in 1924 by one Henry Gerber, who had been in Germany in World War I. Gerber had registered his society with the state of Illinois and had turned to socialism as a model for homosexual liberation. His group, however, was shut down after a few months, and Gerber and his ideas remained obscure. Champ Simmons, the man who brought Harry out in 1929, had told him of Gerber's group, but only in terms of dire warning and did not discuss Gerber's political intentions. Back in Minnesota, Rowland and Hull had discussed the idea of forming some advocacy group for homosexuals, and Martin Block, a New Yorker who later became involved in Mattachine leadership, recalled that "you always heard that there should be a gay organization." He heard it in New York, mostly from older refugees who remembered Hirschfeld [German physician-advocate and author of the 1914 book *The Homosexuality of Men and Women*], though there was little printed information available about that movement. Officially, there was a wall of silence.

In the United States, that silence was giving way to a growing chorus of new voices. Not only had *Kinsey* been published in 1948, but a slew of novels from critically praised young writers drew public awareness to homosexuality. These books included Gore Vidal's *The City and the Pillar*, Truman Capote's *Other Voices, Other Rooms*, and James Baldwin's *Giovanni's Room*. James Barr's *Quatrefoil*, one of the first gay novels to end on a hopeful note, was published in 1950. Few publishers in this period would consider a play or novel for publication unless a gay protagonist came to a bad end—was killed, committed suicide, or was branded as fallen and outcast for life. The five men who sat on the hill overlooking Silver Lake that windy afternoon

in the year of *Quatrefoil's* publication were more than a little afraid. But the prospect of creating a movement by, of, and for homosexuals overshadowed worries of danger.

The five met weekly over the next season, trying out formats for a discussion group on homosexuality. They told their life stories and pooled scraps of gay knowledge to, as Jennings later wrote, "make a little sense out of much nonsense." They were frequently amazed by how much they had in common but had never before expressed, and a heady intimacy bonded them. On Hay's cue, the founders sometimes referred to the group as "Parsifal," after his beloved operatic knights in search of the Holy Grail, but officially they were known as the Steering Committee or, more commonly, as the Fifth Order. Harry continued to live as a married man, keeping his straight world and his new gay world carefully separated. His success at this prompted Rowland to remark in 1987, "By the time Mattachine got started, Harry was already divorced and the wife was out of the picture," though this was not the actual circumstance until the following autumn.

The very real possibility of a police raid and legal persecution required that their meetings always be held in secret. When the occasional guest was invited, it was a standard security process for him to meet a Mattachine member at some public landmark, then to be driven around for a few blocks before being taken to the meeting place. "We did not want to lead the police to our meetings, so we did not give guests the address," said Rowland, and they tried not to use the same location too many times. Blinds were always drawn. ("All those *men*—people would be very curious!") Because they had read that telephones could be used to bug a room, Rowland always put the phone in a dresser drawer and put a pillow over it. When people left the meetings, they kept their voices down.

One Fifth Order member explained the need for these cloak-and-dagger affectations. "It was dramatic because anyone in the early fifties who was gay had a strange feeling of fear. Everyone had experienced something. For instance, picture walking into a bar you'd been going to for some time, not a gay bar but one where gay people had been welcome to drink. Drinks were a quarter there, but one day the bartender says, 'That'll be a dollar to you.' You'd realize with a shock that he didn't want you there. That's a minor example." The laws and customs of the era were stringently anti-homosexual; in California, as in most states, any sexual act except the missionary position between a heterosexual couple was a crime punishable by up to twenty years

in prison. Anyone caught doing anything else could be made to register as a sex offender. Repeat offenders and those whose partners were minors were often sent to Atascadero state prison and given electroshock "therapy," or even subjected to castration. Since any public mention of homosexuality was equated with scandal, few workplaces would retain an employee whose involvement with such an organization became public. Harry knew his own job at Leahy's was on the line, but by this time he had completely reset his priorities. By the fall of 1951, as he later told historian Jonathan Katz, he decided that organizing the Mattachine was "a call to me deeper than the innermost reaches of spirit, a vision-quest more important than life."

It is hard to imagine today what a new and exciting prospect this was in 1950. For homosexuals to meet and share with each other in a nonsexual environment was rare, and for most, being identified as homosexual bore a distinctly negative connotation. Jim Gruber, who joined the Fifth Order that winter, emphasized that "the population in general tended to be sedate in sexual matters, not only in behavior but even what they said, how they phrased things. Talking about gay sex was something you just didn't do." Those early meetings, which continued through the winter and into the spring of 1951, probed topics such as the homosexual personality and society as well as sex. Chief among their challenges was overcoming the negative, cynical mentality about gay life—epitomized by the cuttingly bitchy language of bar talk—so prevalent in homosexual gathering places. Hay and Rowland thus stressed the development of an "ethical homosexual culture" as a steady theme of their work. This sort of social context, where homosexuals were supportive of one another instead of being sexually competitive and acid-tongued, was rare. Harry described it as a "glorious shock" simply to sit in a room with other gay men "and suddenly find one another good and find ourselves so at home and 'in family,' perhaps for the first time in our lives."

This new bond began to edge into Harry's other life. On Christmas Eve, 1950, Harry and Anita threw one of the holiday parties they had come to be known for. Anita cooked large amounts of food, while Harry, as always, meticulously trimmed the tree. The guest list included John and Kay McTernan and Steve and Frances Fritchman among the married couples, along with "several of the fellows in my music class"—Harry's friends Chuck, Bob, Dale, and Rudi. The men from Mattachine played it straight and low-key, but they were still single and long past youth, sore thumbs in a heterosexual environment. Fritchman, the Unitarian minister who had married Harry and

Anita and whom Harry had unsuccessfully approached about sponsoring the organization, was clearly uncomfortable. So was Anita, who must have sensed that Harry's affections lay elsewhere; only days before, to commemorate their first Christmas together, Harry had played Rudi the Gaelic folk song, "I Live Not Where I Love."

As the guests sipped Harry's traditional mulled wine, Bob Hull made his way to the grand piano and played carols. Harry joined him, first alternating accompaniment and then falling easily into fourhanded harmony. Hull suggested they sing "Now Let Every Tongue Adore Thee," an excerpt from the Bach cantata *Sleepers, Wake!*, which both had sung in high school. Hull sang the tenor part, Harry took the bass descant, and then Rowland joined, carrying the melody: "Now let every tongue adore Thee!/Let men with angels sing before Thee!/Let harps and cymbals now unite!/With angels round Thy throne of light!"

The harmony of their voices was laden with emotion, symbolizing—perhaps even betraying—the developing feeling among their secret society. "No mortal eye hath seen/No mortal ear hath heard/Such wond'rous things/Therefore with joy our song shall soar."

As the last notes faded, Harry suddenly noticed that Anita and the married couples were on one side of the room, listening, while on the other side, he and the single men took up a new song.

Gold Galaxie, 2016. A 1965 gold Galaxie parked on Nieto Avenue, a scene that is a constant reminder of home.

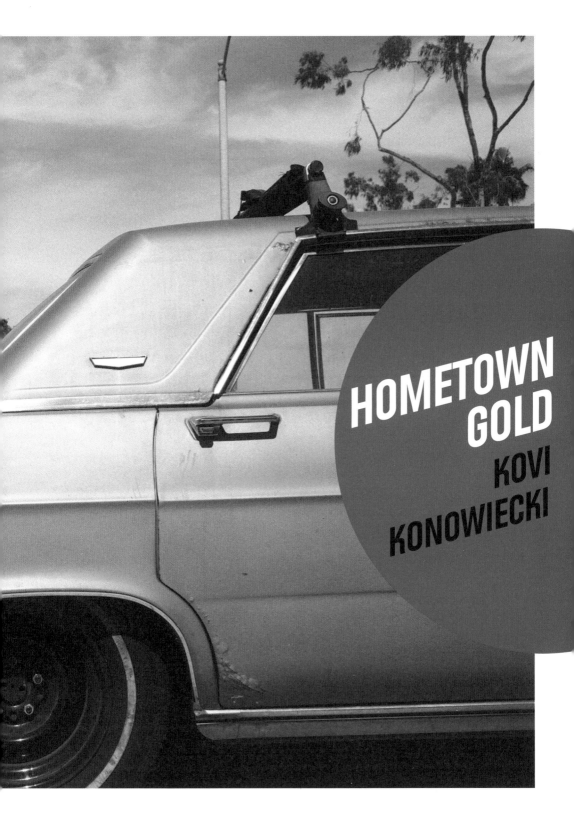

HOMETOWN GOLD

KOVI KONOWIECKI

I was born in Long Beach, California. My parents still live in the same house where I grew up. Long Beach is by no measure a small town, but it has always felt like one to me. Childhood friends always seem to gather on the same street corner; the same golden-hour hue hits the rooftops every summer evening right before the sun goes down. While I have spent nearly half of my life living elsewhere, Long Beach will always be my hometown.

I began creating these photographs to capture the uniqueness of Long Beach—the people and places that I thought made it different from everywhere else. But as I spent more time documenting the city, I discovered that it's actually the things that don't stand out that make my hometown like nowhere else for me. These photographs pay tribute to the elements of Long Beach that many people might find commonplace and unextraordinary, but that highlight the beauty of the familiar. It's that familiarity that can transform the seemingly mundane details of one's hometown into something very personal. These photographs, devoted to the scenes of the everyday—and to the golden light—give a sense of the mysterious, special feeling many of us associate with our hometowns. The feeling does not come from the place itself—it comes from being from the place. The gold Galaxie that sits in my neighbor's driveway year after year will always remind me that I am home.

I also try in these photographs to illustrate how the familiar mood attributed to one's hometown is often unrestricted by the contours of time. For me, the ethereal golden light gives these photographs an aura of timelessness, which keeps the viewer from placing the subjects and places in any specific time period. The people and places depicted in my series exist in a setting created by my perception of home—embodying the feeling that no matter how many years pass, and no matter how many things change, there are certain things that never change.

—K.K.

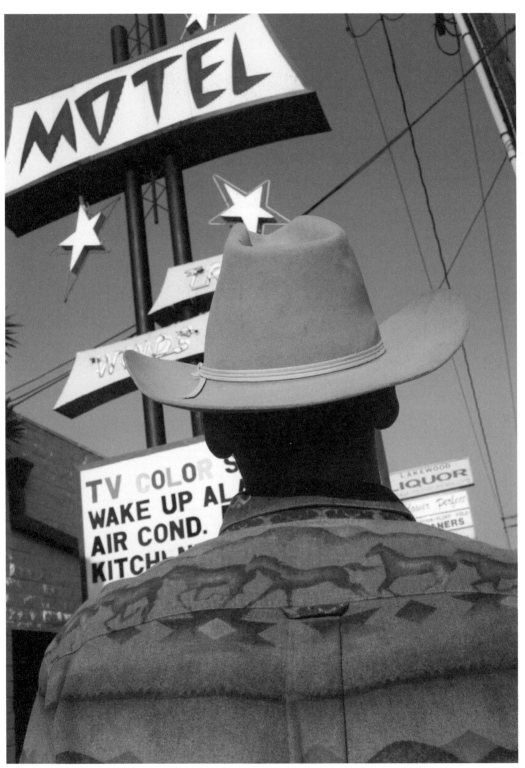

Cowboy, Motel, 2016. A cowboy walking by a motel near the Long Beach Town Center.

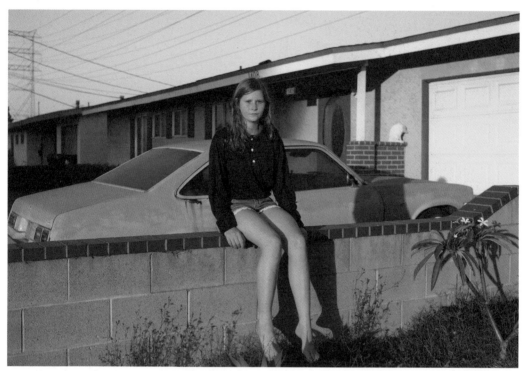

Kierstan, 2017. My neighbor Kierstan hanging out on her front lawn on her first day of summer vacation.

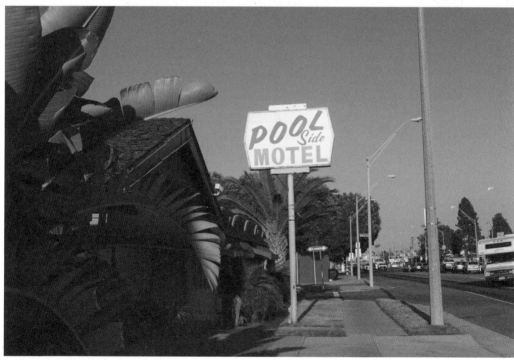

Poolside Motel, 2016. A timeless shot of the Poolside Motel, which has been around since the 1960s.

Shadow, Motel, 2016. Shadows intercept the front of a motel door as the golden hour emerges.

Diner, 2016. An empty booth at my favorite childhood diner, on Bellflower Boulevard.

Service Cleaners, 2016. Golden light bounces off the front door of a dry cleaner on 7th Street.

Boy, Window, 2016. A boy stands in front of a liquor store window across the street from Stearns Park, where I grew up playing baseball.

Girl in Red Shirt, 2016. A girl stands in a parking lot on Pacific Coast Highway after school as the height of the golden hour emerges.

Toy Cars, 2016. Vintage toy cars at the Long Beach Antique Mall, which recently moved from its original location on Pacific Coast Highway.

Superman, 2016. My neighbor in his father's childhood Superman costume, the day of Halloween.

L.A.'s high profile in the almost-international youth movement of the 1960s was aided by its then-growing importance as a center of pop culture, especially television. This article from *Written By*, the magazine of the Writers Guild of America West, is about a TV show that appeared more than fifty years ago, *The Monkees*. It's based on interviews with the show's writers, who had an interesting gig before the current age of celebrity over-documentation and too much information about showbiz everything. These writers knew that their show was something new, but they couldn't know that they were at the dawn of what would soon be known as the New Hollywood. Still, as New York–based twenty- and thirty-something pros, they were mostly unfamiliar with L.A. and were focused on the mechanics of comedy. They drew inspiration from vaudeville and silent movies, not from firsthand knowledge of, for example, student demonstrations. Their goal was to appeal to and capture a young audience, and they were successful. And yet, along the way, they nailed some for-real L.A. phenomena, like feminists in bikinis, Frank Zappa as a role model, and the enduring draw of a Malibu beach house.

WILD LIFE 2
HIGH CONCEPT

HEY, HEY THEY WROTE THE MONKEES

ROSANNE WELCH

THE MONKEES, ORIGINALLY AIRING ON AMERICAN TV FROM
September 1966 through March 1968, was a groundbreaking and
contradictory piece of television provided to a society in flux—a product
that popularized aspects of a new order while it harkened back to more
traditional times. The actors' long hair set them apart from the older adults
of the day, yet they brought the vaudeville antics of the Marx Brothers back
to life on the small screen, where an aging Groucho existed merely as a
stationary game show host.

The Monkees characters inhabited a fantasy Los Angeles where four
members of a struggling rock band live in a Malibu beach house they
(endearingly) can't afford and are shown via smash-cuts and quick montages
in locations such as Griffith Park and Paradise Cove, or popping into sight in
the branches of a statuesque California oak.

Meanwhile, the show's writers were picked for having "New York heads"
and, faced with a demanding schedule, relied on literary classics for plots.
Its producers and directors were inspired by the latest cinematic techniques
coupled with the timing and pratfalls of silent movies.

The program won an Emmy for Outstanding Comedy Series of 1967
and was a marketing machine for recordings that outsold records by the
Beatles and the Stones. It went off the air just before the assassinations of

King and Kennedy, the passage of the Civil Rights Acts, and the Democratic convention in Chicago. It resurfaced in reruns on Saturday mornings in the '70s, on MTV in the '80s, and as recently as 2015 in the IFC (Independent Film Channel) lineup.

It was a creation of a collaborative mix of television talents and reflected a unique time in Hollywood history.

Producers Bert Schneider and Bob Rafelson, who conceived the show, urged the writers, cast, songwriters, directors, film and sound editors, and set and costume designers to experiment. "We're probably the only show with the technical crew built around the content," Rafelson told *TV Week*. "I interviewed lighting men, cameramen, and soundmen. Writers and directors, too. Most of them are young, but the main thing is they had to be involved, had to have an eagerness to swing with the inventive style of the show."

In the wake of *A Hard Day's Night* (1964) and *Help!* (1965), the producers cast four relative unknowns who could act, sing, and play instruments—Davy Jones, Micky Dolenz, Peter Tork, and Mike Nesmith. They hired James Frawley, a 25-year-old theater actor and first-time director, to do theater games with the actors, teach them improv, and become the in-house director. Musical collaborators included young songwriters Harry Nilsson, Neil Diamond, Carole King, Gerry Goffin, Carole Bayer Sager, and Tommy Boyce and Bobby Hart.

The public relations engine that kicked into gear concentrated on the actors and their improvisational spontaneity, creating a myth that a majority of the mayhem was made up on set. But interviews with the principals and comparisons between final script drafts and aired episodes show that the writers introduced much of the frivolity on the page. The show was written by its writing staff with some dialogue improvised by the actors on the set during filming. As Dolenz remembers it, "People don't appreciate how valuable and important the writers of the show were. We always had a finely crafted script with a story, a struggle, Davy falling in love with a girl and getting her out of trouble. Great comedy has some sort of solid story underneath it. And then the humor, as part of the design, was not topical or satirical—so it didn't date."

"We almost never improvised on camera," says Peter Tork. "We would improvise in rehearsals, and if it worked, we'd repeat it for the camera."

Treva Silverman, the only female writer on the show, remembers an interview process for being hired as unique as the one employed to create

the cast (whose auditions are on YouTube). "We were told that the show was looking for the New York head—the quick wit of the New York personality. They didn't even want a résumé. First, they held a meeting in a screening room with tons of dark-bearded, long-haired guys—and me, the only woman asked to be there." Next the producers requested material. Silverman had written sketches for *The Entertainers* (a one-season sketch comedy starring Carol Burnett, Bob Newhart, and Dom DeLuise), and her material made the second and third meetings…. "On the third meeting I cheekily said, 'So how many more of these meetings do you have in mind?' And happily that's when they said, 'This is the last one. It's to tell you that you're on staff.'"

Gerald Gardner, the writer with the most episode credits (22 of 58), agrees it took a true collaboration between writers, directors, actors, and editors to concoct the crazy madcap world of *The Monkees*. He and his then partner (the late Dee Caruso) were hired after a stint on *Get Smart* to help shepherd the first season's scripts.

To develop stories, Gardner turned to the classics. "Many of the most successful ideas are about rejiggering existing ideas. We had to generate 32 stories that first season, so you go to the classics: *Charlie's Aunt* [became Dolenz in drag in "The Chaperone"], *Romeo and Juliet* [became Davy's shotgun near-wedding in "Hillbilly Honeymoon"], identity copies à la *A Tale of Two Cities* [became Dolenz as a gangster in "Alias Micky Dolenz"]…. Then we tried to always create an unpleasant authority figure to give the boys a funny way to clash with authority—and to attract a good name guest star."

Dave Evans, who joined the writing staff after writing greeting cards and working on a pilot with Jay Ward of *Bullwinkle* fame, remembers being given 24-hour access to a screening room for a week to watch and rewatch all the Marx Brothers and Laurel and Hardy films. "At the end of the week he was told, 'Now, go out and write that.'" Evans took the lessons to heart, eventually writing both the first episode to film and cowriting the last to air. He wrote "romps"—physical comedy skits that played to a soundtrack of the actors singing a soon-to-be Top 10 single—for his episodes and then for other writer's scripts, too. Silverman disliked the romps at first, referring to them as interruptions. Writers were requested to write out the entire romp in their first and second scripts, and doing so, she realized, "was a lovely feeling." Later, writers were asked to indicate props and sets and specify a few bits, letting the actors and the director improvise the rest.

Bernie Orenstein, who wrote three episodes during his summer hiatus

from *The Hollywood Palace*, remembers, "We certainly gave them a framework in which to improvise, so more of the improv came in the physical comedy than the verbal."

Few of the writers considered themselves connected to the emerging counterculture. "I was too busy trying to make a living, pay the kids' tuition and orthodontia," Gardner says. He was ten years older than the actors and had come to the show after working as a speechwriter and "humor consultant" on Robert F. Kennedy's successful campaign for the New York Senate. To illustrate his lack of counterculture cachet, he tells of going to the set for the filming of a party at the Monkees' pad. "I wanted to call for the costumer because none of the party guests was wearing a dinner jacket, but the AD said, 'That's not how kids dress for parties anymore,' so I let it go." Gardner also remembers the actors updating a line in a script when Nesmith and Jones were kicked out of a restaurant while pretending to be from the Food and Drug Administration. Gardner's final draft read: "Maybe we should have tried to sell them protection," but in the filmed version it's: "They probably serve bad food and drugs anyway."

To Coslough Johnson, "Co=unterculture meant you were a communist. I was older than the actors and most of the writers since I'd been in the military and then done industrial films—so I didn't even know the smell of marijuana. When you walked into the producer's offices on *The Monkees*, you smelled that sweet smell. I assumed it was sweet tea." Likewise, Bernie Orenstein, who wrote three episodes, says, "My wife accuses me of missing the '60s entirely, and I'm afraid she's right. When I worked on *The Monkees*, I was 35 years old, and my 'regular' job was as a writer for *The Hollywood Palace*"—a show known more for Sinatra and Crosby appearances than for rock music.

Nevertheless, it was Johnson who wrote the speech delivered by Pat Paulsen, playing the Secretary for the Department of UFO Information, in "Monkees Watch Their Feet." When Paulsen tries to place blame for the existence of the aliens, he says, "They want to put the blame on teenagers. Take the war, for example. Whose fault is it? Not ours. We're not fighting. It must be those crazy kids. They're the ones doing all the fighting." Finally, in explaining the only way to rid the earth of aliens, Paulsen declares, "The time has come for us to stop sticking our bayonets into each other and start sticking our bayonets into outer space."

Writer Peter Meyerson became friendly with the actors, hanging out at parties in their Laurel Canyon homes. His scripts became studded with

sly lines that sounded like ad-libs and played to the camera commenting on real-world controversies. He wrote eight episodes, including one with a post-show cameo with Frank Zappa dressed as Mike Nesmith ("Monkees Blow Their Minds"). In his fifth episode, "Monkee Mother," the boys are seen playing dominos. When all the dominos fall someone asks, "What do you call this game?" The answer: "Southeast Asia," a particularly sharp comment considering both Dolenz and Jones received draft notices to the war in Southeast Asia during the first season.

Meyerson also became good friends with Silverman, the other writer who identified with the counterculture, during their two seasons on the show. "I remember going back East and telling my old college roommates that I had started smoking grass," says Silverman. "They were shocked. Pot hadn't quite reached the East Coast to the extent that it had invaded the West Coast."

The presence of Silverman, one of the first female writers to work solo on a TV comedy staff, partly accounts for the strong female voice on the show. It is noticeable that the various young women Davy, Micky, Mike, and Peter fall in love with are almost all feminists, defined by their interest in academia, their working for wages, and the fact that they are active, not passive, in the various storylines in which they appear. Most of the bikini-clad female characters were self-motivated, mature, and responsible. Many held non-gendered careers such as Russian spies, bikers, and rock musicians.

If the writers' notions about comedy had some progressive notes in regard to feminism, they were behind the curve in civil rights and representation of people of color. Although the country's demographics were beginning to change, its white majority gradually declining, the significant increases in percentages of Asian/Pacific Islander and Latino populations were still in the future. Still, the scripts' reliance on caricatures of people of color seems especially antiquated in a show with ambitions to be groovy. Most notable was the deep dependence on stereotypes of Italians as gangsters and Asians as evil exotics. Thanks to the growing clout of the civil rights movement, African Americans fared better on the program, but were still in short supply as guest characters.

The only positive representation of Asian culture came in the final episode, "Frodis Caper," cowritten by Micky Dolenz and Dave Evans, when the Buddhist mantra known as the Lotus Sutra chant helps the boys save the world.

"Frodis Caper" is remembered for obvious, if euphemistic, references to drugs as well as for not-very-veiled criticism of NBC. Frodis, a nickname for

marijuana coined by Dolenz, who remembers "it had to do with Frodo from *Lord of the Rings*," appeared often in other episodes and was also the name given to the off-screen "smoking room" provided for the actors between shots on the set. In the episode, the word refers to a plant-based extra-terrestrial creature held captive by an evil wizard who is trying to control humans through TV sets. The Monkees rescue the plant, which sends out a puff of smoke that mellows the bad guys. It tells the boys, "I don't want to fight anymore. I just want to lay down on the grass and be cool."

Most of the writers felt that the studio and network executives had no idea what the political and drug references meant. According to Silverman, they didn't get the jokes, even though "They were all wearing love beads. While they could accessorize the accessories, they never got the point."

The writers have fond personal memories of *The Monkees* years. Gardner speaks of when the actors took his eight-year-old son Lindsay for a ride in the real Monkeemobile. And he remembers a moment when the program's success came home to him, when he noticed how "the little old mailman on the studio lot brought in a bigger and bigger bag of fan mail each week. He started to have trouble climbing the steps to the show offices, so I told the studio it needed another plan."

Johnson's favorite memories involve walking to his car in the parking lot and "wading through all these kids hanging on the studio fence like vultures waiting to beg for scripts or something from the set." Meyerson names working with Silverman as one highlight: "We used to crack each other up. We would just roll around on the floor and laugh." Another memorable moment he mentions was at the swimming pool at Peter Tork's house where, during a party one night, "the most beautiful girl in the world stripped naked and dove into the pool."

Evans enjoyed knowing the actors individually as friends. "I complimented Davy on a sweater he was wearing as we passed each other on the staircase one day. Without breaking stride, he stripped off the sweater and tossed it to me. I sent it to my ten-year-old niece, who was a great Monkees fan." While he and Dolenz were working on "Frodis Caper," he says, "They had trouble finalizing the deal since it was an actor coming in as writer/ director, so we ended up with one or two days to write the script. I went to Micky's house in Laurel Canyon in a rainstorm lugging my typewriter and found him at home playing clarinet with a house full of other music people, having a jam. So I sat right down and wrote in the midst of that crowd." (At the time, Laurel Canyon's other musical residents included Joni Mitchell,

Graham Nash, Cass Elliot, and Zappa, to name a few.

Silverman smiles at the memory of a conversation with her mother who, when she called, was often told her daughter was in a story meeting. "But after watching the show my mother asked if they were telling the truth, because 'there are no stories on *The Monkees.*'" Her favorite memory is of writing at night. "I always liked writing at night. When everyone would leave at 6 or 6:30, I would start and I would write late into the night. I remember distinctly late one night walking across the studio lot, the lights coming down, the only thing I could hear was the sound of my own shoes clicking on the cement— and I very distinctly thought, *This is Hollywood. This is writing. This is it.*"

Call it the *Moby-Dick* effect: Descriptions of the technical side of work or play are not always just part of the storyline. Sometimes the science is the heart of the fun. If the author trusts readers to get it and has the skill and talent to bring us into how something works, then we trust the author back and find ourselves delighted with that great sense of being there. *L.A. Breakdown,* set among young street racers in 1967, goes a long way toward explaining the persistent appeal of modifying a car designed for transportation into something that can be pushed to drive as fast as possible. Bit by bit, author Lou Mathews gets us up to speed on the mechanics and modifications that drivers hope will charm their races. Bit by bit, we see magical thinking turning obsessive. And bit by bit, we understand in our gut why street racing was born before the Model T and why, every decade or so, news spreads that it's back and it's dangerous.

UNCORKED
STREET
RACE

L.A. BREAKDOWN

LOU MATHEWS

FROM CHAPTER 10

THE NEW SITE WAS A LONG, EMPTY STRETCH OF TWO-LANE

road, between gravel pits, in Pacoima. The absolutely flat landscape was unbroken for miles in any direction, dark and windblown. To the south the county power plants were visible, three separate girdered frameworks housing pipes, catwalks, boilers, and machinery. Two huge smokestacks on opposite sides of each framework were ringed with red and white lights, the red ones on top blinking for aircraft. At that distance they looked like vast paddleboats, steaming toward them.

The cars parked along the unlit road were quiet; the groups out of the cars were small and subdued.

Brody, sharing another beer alongside Willy Lum's Chevy, passed the can to Charlie and pointed a finger toward a dimly visible signboard on the small shelf of land edging the gravel pit. "That guy's my godfather. I ever tell you about him?"

Charlie wandered closer to the fence and peered through; spelled out in gilt letters on a black background, with so many looping flourishes, it was hard to read, the sign said: Vasek Norkus Enterprises.

"Shrewd as hell," Brody was saying. "He used to work with my old man.

I bet I haven't talked to him in ten years."

"What is he?" Charlie said. "Does he run the gravel pit?"

Brody joined him at the fence. "Him and my old man drove trucks out here. Just after the war. The old guy that owned the place decided he was going to die and wanted to go back to Italy, so he offered to sell to Vasek and my old man."

"My old man didn't want to do it. He was going to school nights, so Vasek did it himself. Mortgaged his house and moonlighted and came up with the down payment. It wasn't much.

"The first year my old man made more than he did, but after that Norkus worked out what was probably the only idea he ever got in his life and he just raked it in. It was weird, my old man was the one taking business classes and he laughed at him. Norkus figured it all out by himself. My old man told him he was crazy, but he went to the tax board and it turned out he was right.

"What he did. See, alls he's got is a hole in the ground, but he figured out that every year he's taking out so much sand, so much gravel, and every year there's less left. So he got them to allow for depreciation. Like the oil guys. Cut his taxes down to zero, next to nothing, right? That works great for about ten years, but then finally he gets down almost to bedrock and even with the tax break it's not paying its way.

"So he sells his trucks, shuts the whole thing down, just cools it for about a year, and then he reopens the place as a garbage dump. Wait, it gets sweeter. He sews up every municipal contract in the Valley. Now he's sitting pretty. It'll take twenty years to fill it up. They're paying him to fill it and then he goes back to the tax board. Now he gets another depreciation, because each year the hole gets smaller. They didn't even fight him. He made them laugh."

Brody took his beer back, shook it next to his ear, and stepped on the can. "He's got about ten more years to fill it up. Then comes the kicker. They get it all filled in, he smoothes it off a little, and he's sitting on a hundred twenty acres that can now get zoned residential. The last open land in the Valley."

He squinted through the chain-link. "He lives in a trailer out there. Everybody always figures he's the watchman."

"Too bad your old man didn't get into it," Charlie said.

"Yeah. Norkus fired him the second year."

Several horns sounded faintly. Turning from the fence, they could see a line of headlights showing the contour of the road as they vanished and reappeared. People started to get out of the parked cars.

Walking back to the Chevy, Charlie saw a group of boys around Vaca, with Connie on the periphery, listening to them talk. Charlie was surprised; she'd declined to join him, preferring to stay in the car with the heater. The boys were asking about the Ford, the latest changes. Vaca was pissy with them, and his occasional answers were brief.

The string of headlights was growing larger and the sound of the engines more distinct. Charlie walked to the center of the road and waited.

The lead car, a primer-gray '40 Ford with chrome Lake pipes, well ahead of the others, started braking a quarter mile away, swerving slightly each time the driver hit the brakes or downshifted, characteristic with dangerously lightened and overpowered cars. Charlie moved to the side and watched it coast in, the driver and the boy with him taking a long appraising look at the cars lined up on the shoulder.

They stopped beside Reinhard's Chevy and got out, two clean-cut-looking youths in thin T-shirts and off-white Levi's. Charlie recognized the driver, the taller of the two, long-backed and round-shouldered, as one of the negotiators on his last visit.

The other cars from Stan's were pulling in. Charlie walked down the line to inspect them, noticing particularly a red Corvette that had been towed in. The Corvette had a ladder frame and sat up so high, the driver jumped to get out. A blower with dual quads on top protruded a foot above the cutout hood.

Charlie spotted the starter, Arky Vaughn, at the end of the lane. Vaughn, a dour, hollow-cheeked man in his early thirties wearing thick-framed glasses, was easily identified at a distance by his odd-looking flattop haircut. It was cropped to scalp level on top, long and swept back on the sides like the wings of a nesting bird, a style known on yellowing barbershop posters as a "Chicago Boxcar."

While the mutual inspections went on, Vaughn opened the trunk of his Buick Riviera and began unloading black and yellow rubber safety cones, four tall tripods with reflector studs, and a huge surveyor's tape reel.

Charlie and the driver of the '40 Ford assisted him as he laid out the quarter-mile course. Silently, he marked a line across the road with a chunk of chalk, tossed it to one of the onlookers, and told him to fill it in more plainly. He selected another to hold the end of the tape and started walking backward, playing out the reel. Charlie and the other boy followed him, carrying the reflector poles.

As they moved away from the cars, the darkness became intense. The second time Vaughn stumbled, he told them, "Next time pick a road with some streetlights. Assholes."

He slowed as the tape reached 1,300 feet and had Charlie hold a flashlight on it. When he reached 1,320, he set the tape down and marked on either side with chalk, then extended the line across the road. They placed the reflector sticks, two on either side, one right at the edge of the pavement, the other a few feet away. When Vaughn was satisfied, they started walking back, rolling up the tape.

At the start, Vaughn set out the cones marking staging lanes and then collected his money, twenty-five dollars from each side and the pot. He said he was ready when they were.

Numbers had been daubed on the cars' rear windows with whitewash. Charlie's Chevy was number twelve. The number one car for Stan's, as expected, was the blown Corvette. The '40 Ford was number three. An orange Austin Healey with a Chevy engine was the number two.

Arky Vaughn signaled for the number ten cars, and the drivers began moving forward in the staging lanes. About a third of the crowd had moved down to the finish. Two of Vaughn's friends would determine the winners and had walked down with them, taking their places on either side. They blinked their flashlights to signal they were ready. Charlie stood with Connie near the starting line. This was the time he enjoyed most, the anticipation. His eyes traveled down the line, twenty cars; the variety was astonishing. At the back, the shapes of Reinhard's Chevy and the Corvette next to him were brutally functional. Their lines were chopped by the cutout rear fenders and exposed wide tires and made stubby by their jacked-up stance. One car up, beside Brody, was the sleek and lowered symmetry of the Austin Healey, the lines unbroken and recurving. The colors ranged from drab primer to a roadster halfway back that glinted like a fresh-caught trout with iridescent greens, blues, and reds.

The noise was uniform. All of them were uncorked, and the usual subtleties in the sounds of their idles, caused by differences in engine size, exhaust systems, camshafts, and a dozen other factors, were missing. The only distinctions among the rasping, unmuffled bellows up and down the line were loud and louder, tight and tighter.

The first two cars moved forward, following Vaughn's beckoning arms. Charlie, arms crossed, hands tucked between arms and his sides, watched the

flames dancing on the pavement from their open head pipes. He squeezed the flesh around his ribs as Vaughn began blinking his flashlight. The raw odors of gas, oil baking on exhaust pipes, and hot rubber were distinct and strong.

The familiar sawing roar began as Arky blinked for the start, both cars fighting for traction on the cold pavement. Smoke billowed from the tires, and the waver in the roar ceased as they took off, becoming sharper and sharper until the note broke with their first, simultaneous shifts.

The crowd at the starting line sucked in toward the center of the road, watching them go. Shortly, only their taillights could be seen, and then the reflectors at the end, lighting in the beams of their headlamps. A second passed, and the flashlight on the left side, Stan's side, blinked three times. A mild-sounding cheer came from the crowd at the finish, and both judges' lights blinked to show the road was clear. Arky waved up the next pair.

After the first race, the crowd stayed on the sides. Arky ran them off rapidly, staging the next pair while their predecessors were still on the course. Halfway through the first round, it became clear that the top cars would decide the match. Each side had three wins as the number four cars rolled into the staging lanes.

Gilbert Chavez, in his new Corvette, was racing against a silver Ramcharger with taped-on racing stripes. The start was even, but halfway down something blew in the Corvette. The engine wailed, overrevved; there were sparks in back and under the car from metal hitting the pavement, then it was quiet. The Ramcharger sailed past the finish. The Corvette coasted through and disappeared.

The cars on the starting line shut down, and everyone waited while the roadway was inspected for oil and large pieces of metal. Charlie tried to figure the new order and how much it would hurt them. Everyone on the Van de Kamp's side would move up a notch, and the number eleven car would go against Stan's ten. The Ramcharger looked fast, and that match was probably lost, but the rest seemed close. There wasn't that much difference in the bottom six.

Willy Lum won the next race, blowing off the gray '40 Ford, which seemed to have shifting troubles, by ten car lengths.

Brody and Vaca rolled forward, accompanied by the strong-sounding Austin Healey. The driver of the Healey looked cool. Vaca looked pale and fierce. Brody was grinning constantly and seemed to be enjoying himself.

As Arky waved them up, he appeared interested for the first time that night. The Healey was hanging back; the driver pushed the shifter, and the

car lurched up to the mark. Charlie guessed it was a hydro trans—a beefed automatic—from the sound and the way it idled forward, which meant it would be consistent and that there was some real money in it.

The hydro definitely helped at the start. As Arky started blinking the light, the Healey's driver pushed harder on the brake and brought up the engine revs to just below stall speed.

The front of the car lifted and quivered. When Arky blinked the last time, the Healey driver yanked his foot off the brake and was gone.

Brody got a good start but had several car lengths to make up. It didn't take long; the Ford gained with each shift. Halfway down they were even, and the crowd relaxed. Winding out, the Ford built a sizable lead, and its brake lights showed before the finish.

There was a lull as Reinhard and the driver of the blown Corvette prepared. Reinhard laid down a puddle of bleach in front of his Chevy and made several burnouts, spinning the slicks through the bleach, producing a choking white smoke, cleaning the tires and warming them up to provide better traction.

In the other lane, three people were starting the Stingray. It had been pushed through the line to this point. The driver signaled he was ready, and one boy standing on the opposite side leaned in to hook up jumper cables from a pair of truck batteries. In front another boy with a spray can of ether held open the carburetor butterflies and sprayed the starting fluid down their throats. Both backed away, and the driver closed his eyes tightly and turned the key.

The engine lit with a "whooomp," and the few faces in the crowd that hadn't been watching turned, startled. The Corvette vibrated like a tuning fork. All four tires seemed to dance. The throttle linkage, visible above the hood, moved back leisurely and the ribbed belt turning the blower drive blurred as the engine speed raised. The linkage kicked back as the driver revved it, and the engine and car flexed minutely to the right with the torque. A boy next to Charlie held his ears and yelled, "Sounds nasty." Charlie nodded dumbly. He'd never heard anything like it on the street. The people from Stan's, around the starting line, all had the same irrepressible grin on their faces.

Reinhard's head had whipped around when the Vette started. Now he was looking calmly at Arky and trying, with an ear against the glass, to sense his own engine against the racket of the Vette.

On the line, Arky took a deep breath and motioned them forward. He

took his time staging them, moving once to the side, to be sure the front tires were dead even with each other and with the line. Satisfied, he took his stance in front and pointed the light at them.

The crowd around him held their ears. The engines were equally loud, but the intensity of sound from the Stingray was different, higher in pitch and idle, with more variation. Arky blinked three times for the staging and then again quickly, on about a two count.

Reinhard's Chevy surged and then snapped off the line. With the Corvette it was more of a lunge, as though all four tires left the ground. It seemed to be nearly out of shape, veering to the left, bouncing. The driver backed off a little, corrected, and the Vette roared out in a series of shuddering fishtails.

Reinhard's start had given him a decent lead. It was surprising, because of the noise and awesome acceleration of the Vette, how gradually it diminished. It wasn't until they were through their shifts, two-thirds of the way down, that the Vette began visibly closing in. The crowd stretched, trying to see if Reinhard would hold him off, but it was impossible to judge at that angle and distance.

The flashlights on both sides of the reflectors blinked three times. There was a pause, and then they both blinked again. The crowd came down with a murmur. Arky announced a five-minute break between rounds as pairs of racers started returning from the other end.

Charlie checked his scoring against Arky's and found it agreed. Five wins for Van de Kamp's, four for Stan's, and the tie. He tried to figure, best and worst, what could happen the next round. The best he could anticipate was five-five. He couldn't imagine Reinhard beating the Stingray. If things went wrong anywhere in the bottom six cars, it could easily go six-four Stan's or even seven-three. He went to talk to Brody.

Brody was ebullient, laughing and talking, finishing another beer. Vaca looked cheerful for once. Brody didn't seem worried about the Stingray. Charlie told him it was because he only caught the finish and hadn't really seen or heard the car.

Brody told him, "Don't give up on Reinhard, my man, it's not fast that counts, it's quickest." Charlie looked dubious; Brody continued, "I don't doubt the Vette's carrying more horses, but he's not getting them all on the ground. You saw how he was frying all over the line. He's pushing it too much for a short wheelbase. If Reinhard gets a better start, he'll beat him. Besides, you ever see a blown street car that lasted?" Vaca dug into the bag of beer on the floor; Charlie could see the side of the bag moving and guessed that Vaca

was shaking the can. Vaca held the can out to him on his palm and smiled politely. Charlie said no and went off.

In back of the staging area, the hoods of most of the losers were up. The driver of the Austin Healey was nearly inside the engine compartment, reaching to turn the distributor, while a friend leaned in aiming a timing light at the crank pulley.

The second round began with a loss for Van de Kamp's.

The driver of the first backup car, anxious, overrevved at the line and blew his clutch coming out. The car jumped once and then trailed off to the side, while his opponent made an easy solo pass, looking back most of the way.

Stan's won five of the first seven races in the second round, then suffered their first breakdown of the evening. The '40 Ford matched against Willy Lum got its transmission locked in gear and had to scratch. Brody and Vaca won easily again. As Reinhard and the Stingray came to the line, Stan's held a five-four edge.

Reinhard got a great start this time; he'd dropped the air pressure in his slicks by two pounds, and it made a difference. The tires bit instantly and sent him off almost without slippage or smoke. The Vette's driver was still slipping the clutch to get traction. The Van de Kamp's backers, recognizing the hole shot, began to yell, already sensing the outcome.

Just before Reinhard reached the outer range of the headlights around the start, there was a bang, then a chinking whine, sounding like a fork tossed in a blender, and then the heavy flop of a tire kicking around under a fender. Reinhard's Chevy hobbled off to the side with the right rear slick at an angle, bumping against the wheel well. The Corvette was already by him and coasting for the finish.

The Stan's enthusiasts at both ends were jumping up and down and yelling. "Fuck," Charlie said, "he broke an axle."

Next to him, Connie shivered in her light sweater, her hands balled up inside the sleeves. She asked if that meant it was over.

"Might as well be," Charlie said. "I'll be back in a minute." He started walking toward Reinhard's Chevy.

The Stan's cars and drivers were already back from the finish line and celebrating. The Van de Kamp's cars were parking near Reinhard, ranged in a semicircle with their lights on. Reinhard was lifting a toolbox out of the trunk.

As Charlie arrived, the right side was already up on jack stands. The tire, still bolted to the brake drum and the broken stub of the axle, was in

the roadway. Someone rolled it closer to one of the cars, wedged it against a bumper, and began loosening the lug nuts with a crosswrench.

"What's it look like?" Charlie asked the quiet group behind Reinhard. Willy Lum turned, looking irritated, and then recognized him. "No way, bruddah," Willy said, "Dah slick's holding air, but he got some bad cuts in the sidewall. He got a spare axle, but it's dah kine stock, won' take no strain. He gonna slap it togeddah an slide home."

"We're screwed," Charlie said. He went to watch Reinhard working. Brody was squatting beside him, shining a flashlight, while Reinhard, lying on his side, reached into the axle tube trying to extricate the remaining sheared-off portion of the axle. He wiggled something inside and drew back, bringing out the axle end dripping with heavy oil.

Reinhard brought the jagged end under the light and turned it slowly, examining. Brody pointed to a small recess where the metal glinted whitely like powdered glass. Charlie caught the word crystallized and Reinhard saying something about someone buying it back or wearing it.

Tossing the axle end behind him, Reinhard stood up, wiping his hands. They continued their conversation in tones too low for Charlie to overhear, seeming to reach agreement on something near the end and then laughing together. Charlie had edged closer until Brody shone the light on him and he moved away, embarrassed.

Some of the Stan's racers had drifted down to watch, and finally one of them moved forward to ask, "You guys going to race or what?"

Brody came over to join the Van de Kamp's racers. "Hell yes," he said. "We're ready. You ready?"

"Yeah. We're lined up," he pointed to Reinhard's Chevy. "He going to make it?"

"He's done," Brody said. "I'll race the Healey and the Vette." From behind the Chevy, where he was refitting the brake drum, Reinhard yelled, "Kick his ass, Brody."

There was a hurried consultation among the Stan's racers and near immediate agreement, surprising Brody, who had stood nearby muttering "chickenshit." The boy in front spread his hands and said, "Sure. Sure thing."

The Stan's racers walked off. As Brody eased behind the wheel, Vaca handed him what was left of the last beer and asked, "You want to go for a side bet with the guy in the Vette?"

"Naw," Brody told him, "I don't want to push them too much, they might get antsy. The way it was set up, they don't really have to let us run.

They're just figuring it's in the bag anyway, and there'll be less trouble about the pot if we run."

Watching the Stan's cars lining up, it suddenly hit Charlie that with Chavez and Reinhard sidelined, he would be racing. "Damn," he said and started to run.

He arrived, red-faced and wheezing. Connie was sitting in the car. She looked at him quizzically as he leaned against the door. "Is that it?" she asked.

He grinned at her, between gasps, "...I'm racing."

When he was breathing easier, Charlie got the toolbox out of the trunk and slid under the car to unbolt the cutouts. Connie stood in front, kicking absently at his soles and watching. He pushed out when he was done and opened the hood, checked the water and oil and leaned in over the fender to remove the air cleaner from the carburetor. "Jesus," Connie said, "you're filthy." She brushed at the dirt and grease on his back, stopping when she looked at her hand. She wiped it on his pants as he straightened up, but Charlie never noticed. He tossed the air cleaner in the back seat and fired the Chevy up.

Arky was waving for him, looking irritated. The other car, a black 1959 El Camino with the tailgate down, was already waiting. Charlie took his time moving up, making sure the engine was warm. Arky's beckoning motions became more insistent.

When they were staged, Charlie watched Arky intently. His expression was sour, and his eyes showed impatience. Charlie eased the clutch out a fraction and rolled across the starting line by a foot. Arky's face tweaked with rage; he yelled something as he walked over. Pushing on the Chevy's hood, he rolled it back across the line, still yelling.

Arky turned as soon as he walked back to his spot and started blinking the flashlight at them. Three blinks for staged. Charlie anticipated a quick start and was right. A second after Arky had them staged, he blinked again for the start.

Charlie was already raising his foot from the clutch; the Chevy lifted nicely and surged forward, leaving the startled driver of the El Camino at the line.

Charlie wound it up in first, concentrating on the tach and the tightening sound of the engine. The shift was crisp, the exhaust note hardly broken. Charlie was insensible to everything but the tachometer needle and the noise. His feet and the hand on the shifter and the hand on the wheel were in motion or preparing for motion, without thought. Going into third, his best gear, he could feel the torque, the force, in the pit of his stomach and the small of his back.

He never saw the El Camino pass him. He was close to the finish, then past the finish, and for the first time he saw the taillights beside him. He had to look back to see the blinking flashlight in the other lane to know he'd lost.

He couldn't feel bad. The start was good; he'd never shifted better. The car was running the best it had ever run. He patted the seat beside him and geared down, drifting to the side of the road as he braked. Charlie rolled in next to the El Camino, almost a quarter mile beyond the finish.

The other driver turned off his lights and got out, lighting a cigarette. The match revealed a turquoise blue T-shirt, a sweep of red hair above a high forehead, and pinched features that might have been caused by the smoke. Charlie left the engine running and got out. He pushed in the headlight switch, noticing for the first time his shaking hands.

"Damn good race," the other boy said.

"Yeah, it was," said Charlie. The exhaust burbled fatly, flickering under the cars. "What're you running?" Charlie asked.

"348, tri-power."

Charlie stretched, feeling even better. "Mine's 283, punched thirty over to 301."

They turned as the flattening exhaust notes of the next pair of racers grew louder and watched them through the finish. The lights bobbed, coasting toward them.

"Jesus, it's dark out here," the El Camino driver said. Charlie looked up, noticing the surprising number of stars overhead for the first time. He couldn't remember ever seeing so many. They were almost down to the horizon around him. He suddenly felt tiny. There was an accompanying sensation; he now felt the chill of the night air on his arms, face, and the back of his neck. Two cars pulled in. Another pair were winding out behind them, closing in on the finish.

Maritta Wolff's novel *Sudden Rain* is a tragicomedy of manners, a report from white middle class Los Angeles circa 1972—a domestic-relationship terrain as specific as Edith Wharton's Gilded Age New York. Wolff captures a moment when privileged L.A. children went to public school, divorce laws had just changed, and educated husbands (lawfully enshrined as heads of households) casually patronized their wives. It was a time when, as in this selection, a couple—she having testified at a divorce hearing, he heading out of town on aerospace business—might stop for a steakhouse meal before continuing to the airport, where the departing husband would stroll directly to the gate. Wolff's sure-handed prose keeps us wrapped up in the changing perspectives of her vivid characters, and the story's unusual focus on adulthood is a refreshingly different take on the bygone era. This is the last of Wolff's seven novels, and the manuscript spent thirty years in the fridge before being published after her death.

SEEING HIM OFF
A FAREWELL

SUDDEN RAIN

MARITTA WOLFF

FROM "THURSDAY"

JIM AND CYNNY WALKED TOGETHER ALONG THE DRIVE

beneath the tree limbs, the chill mist damp against their faces. It was dark now, except for the lights that twinkled through the leaves.

"Would you rather drive, darling?" she asked as they approached the long, glistening bulk of the car.

"Not unless you're too tired."

"No, I don't mind." She walked on around to the driver's side, reaching into her purse for the keys.

He opened the door on the passenger side and tossed the suitcase and a raincoat into the back before he entered the car. The attaché case he placed carefully between his feet, then fastened the seat belt.

"Where shall we eat, love?" she asked.

"How about that steak place off the freeway? I can't think of the name of it, but you know the one I mean."

"Fine, it shouldn't be too crowded this early. Isn't it funny, I can't remember the name of it either."

He turned to look over his shoulder, pointedly watching for traffic as she backed the car out of the drive, and Cynny's face was momentarily

amused. He sat back then, reaching for the attaché case and lifting it onto his knees. His mind turned back to the project it represented, and with an enormous sense of relief he was again immersed in it.

Several minutes later Cynny turned her head, but at the sight of his absorbed face in the dim light she remained silent, giving herself up to her driving instead. It was a full fifteen minutes, when she had turned on the windshield wipers and the sibilant hiss of the swinging blades was suddenly loud in the quiet car, before his concentration was broken.

"I'm sorry," he said quickly. "We're nearly there. I must have been half asleep."

"That's marvelous. It's good for you to rest."

He glanced to where the slender blades cut twin dark swaths across the blurred glass. "Hey, it's raining!"

"Just a drizzle. Wouldn't it be wonderful though if it really would rain?"

"It looks slippery. You'd better slow down."

"It's not that wet. I'm being careful, darling."

He stretched, moving his shoulders against the seat back, and yawned. The few minutes he had spent in a preliminary run-through of his project had been highly satisfying and reassuring. This project had been under his supervision since its inception, and he wanted its approval very badly. However, for the moment at least, he felt a complete confidence. No one else could have come close to it, they could not possibly miss. And with his confidence came a sense of well-being, and a heady relaxation of tension.

The car seemed particularly snug and intimate against the wet night. He discovered that he was looking forward to a well-cooked steak. And he was aware also of the scent of his wife's perfume and Cynny herself beside him, her hands on the wheel, the poise of her smooth, dark head and the clarity of her profile.

"You know, Cynny, you drive a hell of a lot faster than you used to," he said, teasing. "How many traffic tickets are you holding out on me anyway?"

She glanced at him quickly, caught by the sudden shift in his mood, and found his face indeed relaxed and smiling. She laughed. "No tickets, knock wood. I think you've simply gotten used to my poky driving after all these years."

Her smile lingered, and he felt the faintest quickening of an old desire. Cynny in her own way, he thought, with a certain mild surprise, was still a damned attractive woman. Never a breathstopping beauty, but something more subtle and indefinable. Whatever it was about her, it had been there

in the turn of her head and the shape of her smile, just as it had been when he'd met her at somebody's dull dinner party a hundred years ago. It came into his mind to wonder with more curiosity than emotion if she had ever had a lover or ever wanted one.

She set the right turn signal blinking. "Good," she said as the car rolled to a stop in the wide driveway. "The parking lot is half empty. We won't have to wait for a table."

The red-jacketed parking attendant offered his hand as she slid from the seat, and Jim came around the front of the car, where fine drops danced in the beams from the headlights. Together, they ducked beneath the overhanging roof. The restaurant was a low, sprawling, nondescript structure with faked timbering over stucco walls and windows of leaded colored glass.

"Jim, I didn't see a sign when we drove in, did you? Do you think it could be that the reason we never remember the name of this place is it hasn't one?"

He laughed with her and reached out his hand to the back of her neck in one of his rare gestures of affection, his fingers moving against the soft, warm skin inside her jacket collar. She looked up at him, her face pleased, and rubbed her cheek against his hand.

He opened the door, and they entered an interior that was considerably darker than the parking lot and pungent with the aroma of smoking charcoal. On the left was a bar, where bottles and glassware twinkled in the gloom, and ahead, a large, half empty dining room. They were seated immediately at a small table against the wall, and Jim consulted the menu for them both, holding the outsize sheet of glossy cardboard into the candlelight while Cynny hunted in her bag for cigarettes.

After the food was ordered, the point established that they had a plane to catch, and a tall drink delivered to Cynny from the bar, she wriggled in her chair suddenly, her face lighting. "Jim, this is fun! Ye Olde Anonymous Inn seems terribly cozy tonight. It must be the rain. Do you realize this is the first we've had since last April? I hope it absolutely pours! Have some wine, love. Let's get smashed and miss the plane and the hell with the PTA!"

He grinned at her. "Oh, sure! I have to do enough drinking on these trips as it is. Cheers anyway."

"Damn! Then it looks like I'm stuck with the PTA. Cheers, darling. To your trip. Is it something important?"

"Yes, fairly. I've been in on the development of this gadget from the beginning. I'd like to see it go."

"We'll drink to that then. It's NASA, isn't it? Would it be an important contract to get?"

He shrugged. "Any contract these days is important. You know how it works. NASA was never a big customer necessarily, they buy two of this and a half dozen of that. But this gadget, for instance, could be used in a few other places in a modified version, the Air Force for one, maybe later on even commercial aircraft. If it meets NASA specifications, we're about guaranteed that there'll be some damn big contracts coming along in the next year or two."

"It sounds exciting. Could you tell me about it, or is it terribly classified?"

"Actually, it's pretty technical. I doubt if you'd find it all that interesting anyway."

"I suppose," she said. "Jim? Speaking of the office, something I've been meaning to ask you. Dave Friedman seems to work a lot at night and overtime these days. Must he, or is it his own idea?"

"Why? Has Nancy Friedman been bitching about it to you?"

"Oh, Jim, of course not! I've just gathered, talking to her, that Dave was working rather long hours and was away from home quite a bit. It's my own curiosity. I just wondered if he had to be or whether he chose to be. Actually, it's none of my business, is it?"

"Don't be silly. It's a hard question to answer, that's all. Dave is in on two or three things at the moment, and he's not a clock watcher. Dave's a pretty bright guy, you know. He's liable to do some pretty interesting things one of these days, particularly if he has the kind of wife who won't be nagging him about the hours he keeps or on his back about something else half the time."

"Well, Nancy certainly isn't the nagging type. She adores Dave, she's very proud of him and terribly interested in what he does, as much as she's allowed to be."

"Good. Then what's the problem?"

"No problem," Cynny said mildly. "Just that ever since the summer, Nancy has seemed a little downbeat. It isn't like her. It occurred to me it might be because she is alone too much. But it's certainly nothing important. Nancy is a very bright girl, too. She'll work it out."

"I assume you know that the fact that you're buddy-buddies with Nancy Friedman sows consternation through the whole echelon of younger guys at the office?"

"Oh, Lord, office politics! As bad as the Army. I suppose it's bad form for me to fraternize with the wife of a junior officer. Darling, you don't object, do you?"

"Hell, no. Not if she amuses you. Frankly, I've never found Nancy Friedman all that amusing myself. Too many freckles and a mind like a little steel trap."

Cynny giggled. "Jim, what a thing to say! Well, I like Nancy very much. She always has something else to talk about besides babies and shopping and Dave's career, and that's a switch, I promise you. There, isn't that our food just coming?"

"About time! What do we have on for this weekend, incidentally? I've already canceled my appointment at the barber's and my golf date for Sunday morning."

"Tomorrow night we had that fund-raising thing, cocktails and an art show. I'd love to get out of it anyway, now I have an excuse. Saturday night we have ballet tickets."

"There's a possibility I may stay over Saturday night and have dinner with a guy in Huntsville," he said while the waiter put the hot plates on the table. "You'd better get someone to use the other ticket. What about Sunday?"

"Only the McClures' dinner party."

"I'll be back for that in any case. How is your steak?"

"Just right. Delectable. How is yours?"

"All right."

Conversation dwindled as they ate. The dining room was beginning to fill up now, waiters and busboys hurrying between the tables. Jim's mind turned again, in spite of himself, to the plans in the attaché case. There were admittedly a couple of sticky spots in the presentation, but then he had not yet seen the final figures from the computer; he had reserved those for study on the plane. If they were not what he expected them to be, he was in trouble beyond question. Some of his confidence began to drain away at the thought, and with it the flavor and aroma of his food. Anxiety prickled within him, and for the remainder of the meal he was silent and preoccupied.

The plates were cleared away and steaming cups of coffee placed before them. Cynny reached for her cigarettes. "That was very good," she said contentedly. "Look, there are people waiting in line now for tables, we got here just in time."

He made no answer, and she peered into his tense face.

"Darling, are we running late? We needn't drink the coffee if you need to go."

"No, we have time," he said shortly. He struck a match for her cigarette, and she leaned forward to the small, wavering flame.

"Jim, what is it? If your steak was too rare, you should have sent it back."

"Nothing's wrong, the steak was fine. Waiter! Waiter, could we have some cream here?"

But there was no doubt of it, she was thinking, the good humor with which he had entered the restaurant had unaccountably vanished, and she felt her own spirits begin to fall accordingly.

"I haven't told you about my crazy afternoon," she said finally, her voice deliberately light. "Today was the day I went to court with Janet Anderson."

"God, I forgot. How did it go?"

"Honestly! Do you realize that this makes three or four times I've done this? And every time I swear I'll never do it again. First we had lunch, of course, with everyone being too bright and witty for words. Poor Janet! And it was hot and smoggy downtown, and I had terrible butterflies. The actual court thing wasn't that bad, it's just that that whole place is so fantastic. And depressing. Jim, it was so sad, after it was over I went to the ladies,' and I found this girl, she was very young and—"

"What did you say, anyway?"

"You mean on the stand? Oh, just the usual. You know. That we'd been to dinner there when Fred hadn't shown up. That Janet was upset and losing weight and all that. Actually, it was all more or less cut and dried; the lawyers had worked out the property settlement a month ago."

He moved impatiently upon the soft vinyl chair seat. "Fred Anderson is a fool. To uproot his whole life like this! Not to mention the community property. Incredible."

"Oh, I don't know, I hear that this girl of his is very nice. I expect Fred thinks it's all worth it for a little happiness, don't you imagine?"

"Happiness!" He snorted. "To start over again with a new family at his age? To cripple his business in a property division and then pay Janet a whacking alimony out of his half besides? You call that happiness? Even if this female of his was an angel straight from heaven, he'd have to be crazy. Fred's old enough to know better, for God's sakes!"

She was silent behind a blue drift of cigarette smoke, and what he construed to be the implied criticism in her silence stung him.

"Ah, you girls get very sentimental over happiness, don't you?" he said, more bitterly than he had intended. "But then you can afford to be. California community property laws were made for women. You have it all your way in the courts. A man has to be out of his mind to go that route."

There was a hurt in her face for an instant that he did not altogether understand.

"You make it all sound like a business transaction," she said. "As though that were the only reason for anyone to keep a marriage together anymore."

He stared at her and wondered what precisely she was thinking, and he felt a small, cold trickle down his spine.

"Well, as you say, it's all damn depressing," he replied in an effort at lightness. "Why can't everyone be sensible like you and me? Waiter? I'll have the check now."

A moment later, with his wallet half out of his pocket, he was smiling suddenly. "Well, well," he said. "Look who's here! Our chief competitor, Mr. California Aerospace Electronics himself! Obviously, we're not the only ones who've discovered that this is the best place to eat on the way to the airport."

"Where?"

"Over against the other wall. They've just been seated." Jim appeared once more to be in very good spirits indeed.

Cynny looked discreetly along the row of tables, her gaze coming to rest finally upon the thickset, vigorous-looking man with the short, graying hair. "Ah, yes," she said. "Tom Fallon. I didn't see them come in. He really is very striking looking, isn't he?"

"Actually, he's a nice guy," Jim said. "If he weren't such a cocky bastard. The trouble is, he's nearly as good as he thinks he is. But this is once when he could save himself a trip."

"You mean you think he's off tonight on the same errand you are? How funny. Here you are eating in the same restaurant, maybe you'll end up flying on the same plane."

"He's off on the same errand all right, but I doubt if we'll be on the same plane. They'll start him at the other end of the appointment list."

Cynny glanced again across the dark, crowded room. Tom had donned a pair of black-rimmed glasses to read the menu in the candlelight, and his companion, a small woman with streaked, wispy blond hair, was talking to him animatedly.

"I don't think I've ever seen his wife before. She has a very nice face."

Jim was concentrating momentarily over the check. "Who? Oh, Tom

SUDDEN RAIN

Fallon." He looked again in their direction and then laughed. "Well, she may have a nice face," he said cheerfully, "but for your information, she is not Mrs. Fallon. Old Tom's quite a woman chaser, you know. At least it's a switch. Mrs. Fallon happens to be younger and prettier than that female, whoever she is. Have you finished?"

"Yes. Is there time for the ladies'?"

"Just. I'll meet you in the lobby."

A moment later, when Cynny left the powder room, she caught an unexpected glimpse of the pair back in the dining room. The menus had disappeared; they sat now with drinks before them, englobed in mellow candlelight. She saw Tom snuff out a cigarette and reach across the corner of the table to take the woman's hand in his, making of the commonplace gesture something so touchingly intimate that Cynny halted, rooted for an instant in the dim corridor. The woman looked at Tom, her face shining. He spoke to her briefly, she nodded and placed her other hand over his caressingly. For a moment they were silent, engaged in some private communication, an aura of love and tenderness enveloping them as tangibly as the candle glow. Then the moment was gone, and they both moved at once. Tom reached for cigarettes, and the woman tipped back her head to laugh, bursting into rapid speech and tugging at his coat sleeve teasingly, her face crinkling with merriment.

Cynny came back to herself with a guilty sense of voyeurism. There was an inexplicable lump in her throat and tears smarting beneath her eyelids. Oh, now really, she mocked herself as she set off again.

Jim waited, squeezed against the wall in the crowded foyer, glancing at his watch just as she approached.

"What were you doing in there anyway?" he asked pleasantly. "Never mind, we're timing out just right. He turned away to push open the heavy wooden door. My God, is that fog? All I need is that damn bus ride out to Ontario tonight. What's the matter, Cynny? You're very quiet all of a sudden."

"I was hoping for the rain, but now it's stopped. We need rain so badly, everything's so dry and parched and dusty. Sometimes I can't bear it, I find myself absolutely longing for it."

"You should be used to doing without it by now," he said lightly. "You know it never rains in Southern California."

"You always say that," she said. "Ah, but don't forget, when it does, it pours!"

L.A. SUPERLATIVES

A FEW ROCK STAR MOMENTS

- **1935:** Aaron Thibeaux "T-Bone" Walker moves from Dallas to Los Angeles, where he pioneers jump blues and electric blues and helps integrate L.A.'s music-club audiences.

- **1960:** John F. Kennedy delivers his "New Frontiers" speech before 80,000 people, at the time the largest live audience for a political speech.

- **1966:** Brian Wilson calls KHJ radio to offer them a chance to broadcast the just-completed tape of the Beach Boys' song "Good Vibrations." The nation's top-rated singles station accepts.

- **1967:** More L.A. locals (seventeen) are depicted on the Beatles' *Sgt. Pepper's* album cover than from any other city in the world.

SOCIAL JUSTICE SEESAW

- **1921:** The Ku Klux Klan comes to L.A. with support from church leaders. In 1924, it stages the then-largest Southland demonstration, of 5,000 people, to decry the International Workers of the World.

- **1947:** *Vice Versa: America's Gayest Magazine*, the nation's first lesbian magazine, begins publication. Its nine issues are written and distributed via carbon copy by a secretary at RKO Studios pen-named Lisa Ben.

- **2013**: Patrice Cullors of Los Angeles meets Alicia Garza of Oakland and Opal Tometi of Phoenix through online forums hosted by Black Organizing for Leadership & Dignity (BOLD) and they create #BlackLivesMatter.

- **2018**: Seventy-five percent of the homeless people living in Los Angeles lack access to shelter.

HIGH LOW POINTS

- **1924–26**: Albert A. Michelson almost achieves a new definitive measurement of the speed of light from Mt. Wilson Observatory but is undermined by haze from forest fires and an earthquake.

- **1933**: L.A. becomes the first American city to force its mayor (Frank Shaw) from office via a public recall vote.

- **1963**: When the Baldwin Hills dam collapses, killing five people, live coverage by helicopter marks a new era of news reporting.

- **2002**: L.A. experiences its biggest traffic collision, the fourth largest in world history: an accident on the fog-bound 710 that seriously injures five people and damages 216 vehicles, destroying seventy.

- **2017**: Fifty-nine percent of people in the city of Los Angeles speak a language other than English at home, the highest percentage of the five largest US cities. In East L.A., a CDP (Census Designated Place), the figure is ninety percent.

- **2018**: There are no Angelenos on *Forbes*'s list of the world's top-ten billionaires.

AM NOT, ARE TOO

- No neighborhoods that have had movements to secede from Los Angeles have been successful, although efforts have been launched by Venice, Hollywood, the San Fernando Valley, and a consortium of harbor-area communities. West Hollywood and East L.A., as unincorporated areas of Los Angeles County, have petitioned the Local Agency Formation Commission for cityhood, WeHo successfully.

- Orange County was originally part of Los Angeles County. Secessionists lobbied the state legislature for nearly twenty years until successfully breaking away in 1889.

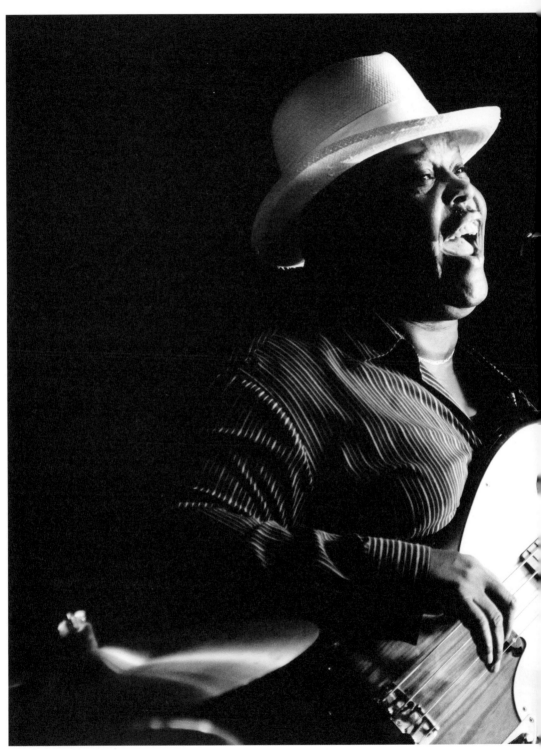

Blues Bass. Lester Lands at Lucy's 51, October 11, 2013

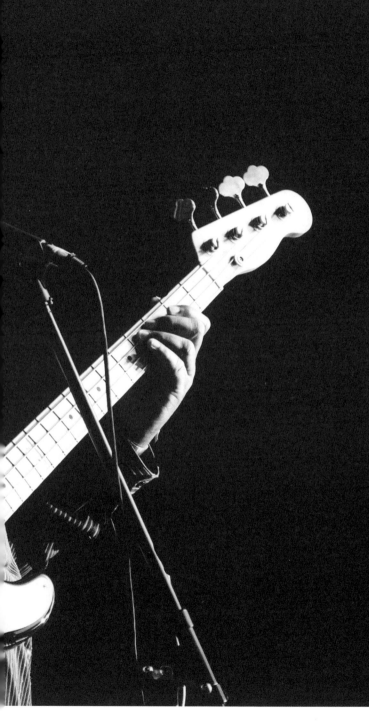

THE RIGHT NOTES

WARREN HILL

As a photographer, I feel compelled to capture the people, the moments, and the memories tied to some amazing places. My camera has given me the opportunity to meet South L.A.'s most intriguing musicians, artists whose very names—Southside Slim, Guitarlosopher, Bobby "Hurricane" Spencer—make it clear the jazz and blues scene is alive and well. And despite those down-on-my-luck lyrics, I've never been to a sad blues jam. Head over to Leimert Park, to the Barbara Morrison Performing Arts Center, where musicians gather; continue south to the World Famous Barnyard on South Main Street and Bell's Blues Workshop, located in Franklin Bell's garage on Colden Avenue. Bell's is open only on Sundays from 4 p.m. to 9 p.m., but considering that the $10 cover includes dinner, Sundays just got a little bit better. Come ready to party—the locals are dressed to the nines, and the musicians are in the zone. I feel the same when I'm behind the camera. It's an extraordinary experience to press the shutter and somehow participate, understand, and be inspired to hit all the right notes, highlighting the story of a very special part of Los Angeles.

—W.H.

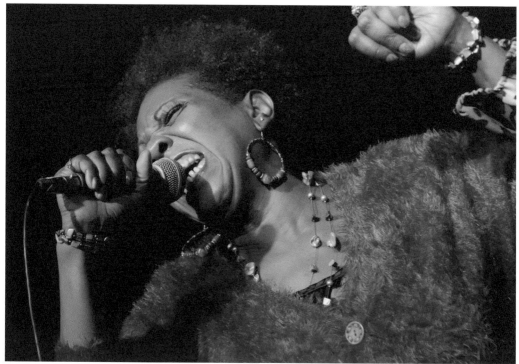

The Texas Songbird. Sherry Pruitt at the Barbara Morrison Performing Arts Center, November 8, 2013

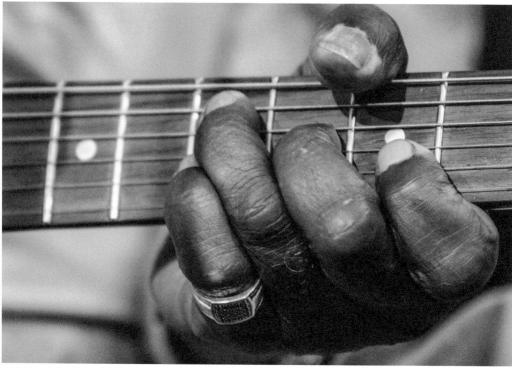

Don't Take Nothing. Jamie Powell at Lucy's 51, December 24, 2012

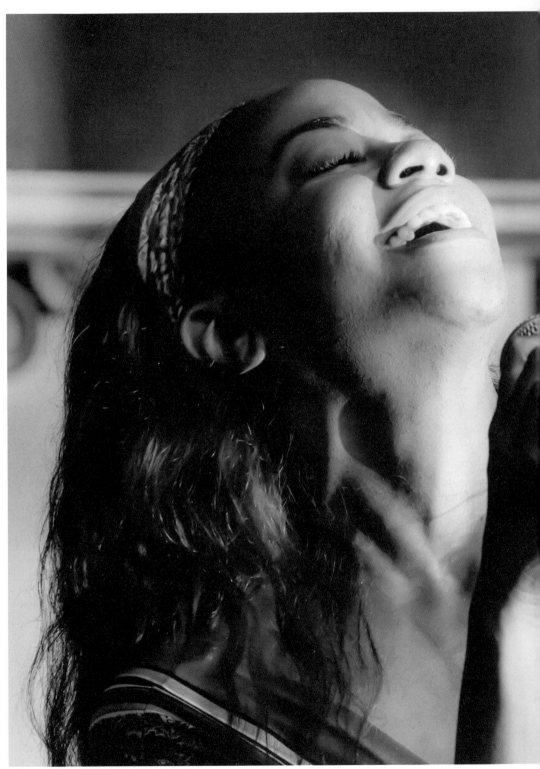

The Great Johnny Taylor's Daughter. Tasha Taylor at Lucy's 51, September 28, 2013

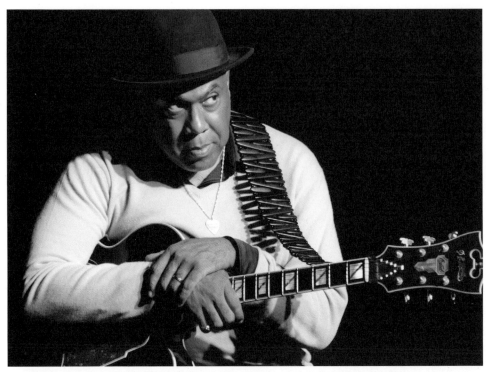

The Jazz "Guitarlosopher." Jacques Lesure at the Barbara Morrison Performing Arts Center, October 11, 2013

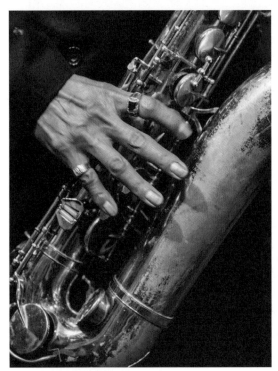

Blues Sax. Bell's Blues Workshop, December 24, 2012

Sherry Pruitt. Barbara Morrison Performing Arts Center, August 23, 2015

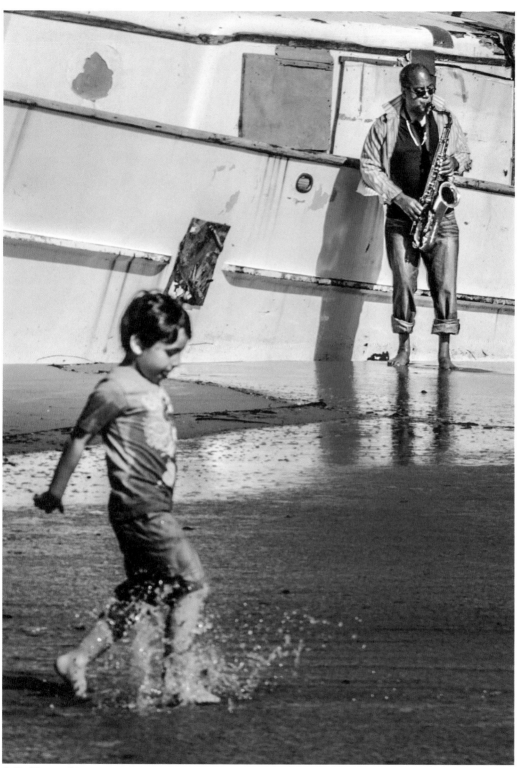

Bobby "Hurricane" Spencer. Playa del Rey, April 30, 2014

Broadway. Bell's Blues Workshop, December 24, 2012

Dave's Horn. November 8, 2008

The Queen. Barbara Morrison, April 5, 2014

Blues Mystery. Unique Social Club, February 28, 2014

Sweet Baby J'ai. Leimert Park Blues Festival, May 11, 2013

Stylin'. Bell's Blues Workshop, December 29, 2013

Brandon Coleman. Leimert Park African Marketplace, September 1, 2013

Comparing conditions and practices in L.A. and N.Y. goes back to at least L.A.'s early American period in the 1870s (see "The Currency Question," page 10). Comparing is different from complaining, of course. To compare with flair, you must be familiar with both places. A novice could have learned the technique at any of Southern California's many hometown picnics, popular gatherings between 1900 and 1950, where you would hear L.A. ranked against "back homes" ranging from Japanese prefectures to Iowa farm towns. At a guess, locals began specifically complaining about comparisons from New York refugees in the 1970s, when conditions in both cities sucked. The situation brought out New Yorkers' instinct for ego strengthening, which wasn't compatible with Angelenos' default de-escalation approach (repeating a tight-lipped "we're cool" mantra that makes us seem dumb to people from anxiety zones). By the 1980s, the editors of *L.A. Style* magazine knew it was an ongoing two-way conversation. They devoted a column to bicoastal comparisons called "L.A./N.Y./L.A./N.Y.," which turned out to be an amusingly good thing. This piece ran in August 1989.

BICOASTAL BITCHING
WEATHER REPORT

SUMMERS IN THE CITIES

PATRICIA FREEMAN

WHEN I LIVED IN CALIFORNIA, I COULD NEVER MAKE A trip back home without encountering some incredulous friend who would ask, "Don't you miss the seasons?" This always seemed a perfectly ridiculous question, considering that two of four seasons in the East are unbearable, and spring and fall put together don't last as long as *War and Remembrance*. It also suggested that L.A. doesn't have any seasons at all, which of course it does: Rose Bowl, Palm Springs, Beach and Summer.

Summer, as everyone in Los Angeles knows, starts in about mid-August and lasts until Halloween.

It's the only time of year when people can complain about the weather, and they do, mightily. I used to. I remember how the wind would die and the air would turn to rust over Arcadia and Hawaiian Gardens and all those other places with paradisiacal names and miles of transmission repair shops. Even in our ocean-view apartment we'd drag out the sooty old fan my husband's grandmother had given us, drape ourselves over the least adhesive piece of furniture we could find and wait for deliverance. Sometimes, when I would drive through the parched, post-nuclear landscape, my lungs sucking in some mixture of oxygen and ground glass, I would feel as if I were getting a glimpse of hell. But now I know better. I know that the netherworld must be just like summer in New York.

You forget, when you live in L.A., how truly uninhabitable Manhattan is from June until September. I'm not talking about a heat spell, the three- and four-day stretches of crematorium temperatures that you get in Los Angeles. I'm talking about three months of feeling like you've fallen into a Jacuzzi that's never been cleaned. A sort of green slime hangs in the air, which smells of dead guppies. The bed sheets grow moss. You don't broil when you go outside, you poach.

It can all be traced to the fact that Donald Trump's precursors built New York on a swamp. This can be quite disorienting when you've come from a place whose founders settled in a desert that couldn't sustain life without stolen water. You just have to think of summertime as a bicoastal reminder of mankind's relentless drive to erect cities in areas completely unfit for human habitation.

I must admit, though, that this only works until sundown. No matter how long it's been since you've lived in L.A., a summer night will stir preconscious memories of rides in convertibles and blossom-scented breezes. Something in you will recall the sweet anticipation of waiting for the heat to break, the blessed sensation of watching the incandescent day sink over the horizon. Even in Manhattan, like Pavlov's dog you will interpret the day's end as a signal of impending relief. Forget it. In defiance of every known natural law, New York gets hotter after dark. You can try opening your window, but you won't get any air—just salsa music and sirens. I would never have survived my first summer if I hadn't bumped into a friend who had once worked as a foreign correspondent in Vietnam. She taught me her tropical survival technique: Take a cold shower in your nightgown, then lie perfectly still in front of a fan until the gown dries; repeat until morning.

I think that perhaps I could cope if it were just a matter of bad weather. But what makes summer in Manhattan really torturous is the baffling local approach to clothing. At least in L.A. you can go out to lunch in your underwear. This would make a great deal of sense in New York. In fact, the most logical plan would be to glass the whole place in like a steam bath and let everyone walk around in towels. But no, pantyhose are mandatory— though your legs will feel like boiled weenies in overstuffed casing. As my mother explained to me when I took the bus to meet her in the city during my freshman year of college, "In New York only prostitutes wear shorts." (In L.A., by contrast, only the homeless wear coats.)

At first I thought it was sheer perversity, this mass refusal to dress for the weather. But after a while I began to see some sense in it: Wearing a lot of

clothing keeps you from sticking to things. Imagine, for example, walking down Broadway on a summer afternoon in flip-flops instead of wing tips. If you didn't find yourself adhering to the pavement outside Gray's Papaya, your toes would lie caulked together with mucilaginous lumps of hot dog bun by the time you passed Nathan's.

The amazing thing is that New Yorkers don't gripe much about any of it—the dry cleaning bills, the hostile, overheated hordes that hang out on every street corner, the ever-present possibility of being pressure-cooked in the subway. Fatalists all, they figure the best they can do is to escape perdition on weekends.

At other times of the year, there seems to be a citywide contest to see who can work the most ridiculous hours. No matter how late I leave the office in winter—I think my record is 2:15 a.m.—the lawyers in the Exxon building across the street are still composing briefs. At the company where I work, no one joins the Mommy Track; they're all on the Divorce Track—out for a midnight snack and a quick martini or four, then back to work.

But come summer, everything changes. On a June Friday at 5 p.m. you can shoot a cannon through every office on Sixth Avenue. Everyone's gone to the Hamptons or Fire Island, and *The New York Times* food section is full of articles advising young stockbrokers on how to whip up a batch of Pink Peppercorn Sea Bass with the seven friends they've rounded up to help them pay the rent on their summer houses.

No comparable phenomenon exists in Los Angeles. People in L.A. stay home on summer weekends. They wash the car, barbecue some chicken breasts, check out Dollar Days at Sav-On. It's not that they haven't got enough credit cards to get away. It's just that any attempt to leave the city seems futile. You get on the freeway after a week of work, and four hours later you're in Tujunga. Unless your idea of a change of scenery is a new Bob's Big Boy, you might as well stay where you are.

The good thing about spending summer in New York is that for a few weeks you stop feeling the weight of other people's wealth. Suddenly you're not the only one without a cashmere coat, a co-op and a $100 haircut. Everybody who has anything is gone. It's just you, the bag people and the old men who spend their days sailing miniature boats on Central Park's pond. It's a feeling you never get in L.A., especially in summer, when the night air seems to tinkle with the sound of parties you weren't invited to. In New York, you don't wake up to the hissing of a million sprinklers watering a million wide green lawns. Where you are will do, and what you have is enough. At least until September.

Scholars sometimes describe the indigenous villages of what is now roughly coastal Los Angeles (from Malibu to San Pedro and including the southern Channel Islands of San Clemente, San Nicolas, Santa Barbara, and Santa Catalina) as having been a connected group of maritime settlements. Contemporary activists who are exploring ways that traditional studies can empower today's Native American communities are taking that concept a step further and reimagining Southern California as a Pacific Rim canoe culture linked to other seafaring peoples. As they decolonize the map of L.A., documenting the repeated displacement and segregation of Tongva villages, activists have helped individuals reaffirm their group identity through education, ceremony, and the revival of practices revolving around the environment. This essay, about a seagoing vessel central to a community's traditions and dreams, was first published in 2016 in *News from Native California*, a quarterly magazine "devoted to the vibrant cultures, art, languages, histories, social justice movements, and stories of California's diverse Indian peoples."

A PADDLER'S JOURNEY REVIVAL

GROWING UP WITH MO'OMAT AHIKO

RIVER GARZA

MY JOURNEY AS A PADDLER BEGAN WITH A DREAM.

A dream that came to my aunt Cindi Alvitre years before I was born. In this dream she saw the Santa Ana mountains become the body of a warrior. The warrior's eyes were shut, and lava spewed from its face. Later in that dream, ancestors appeared before her paddling in unison and singing their songs in wooden plank canoes on a lake. The warrior opened its eyes and the lava stopped flowing. The mountains that made the warrior's body split, and in between them Pimu (Catalina Island) appeared. Two weeks later a philanthropist interested in indigenous maritime cultures named Jim Noyes contacted my Aunt Cindi and asked her if she would be interested in building a Tongva *ti'at* (plank canoe). She said she had never heard of a *ti'at* at the time but the vessels he described were the canoes she had seen in her dream. Thus a relationship formed between the two and that sparked the beginning of the Ti'at Society and the eventual birth of *Mo'omat Ahiko (Breath of the Ocean)*, our community's *ti'at*.

The Ti'at Society formed as a collective of Tongva/Gabrieleno tribal members and other native folks living in the Southern California area who were involved in cultural revival and interested in local maritime culture. It took our community years to build *Mo'omat Ahiko* and prepare her for her

first voyage. She was born in Santa Barbara in 1992. She is twenty-seven feet long, weighs well over seven hundred pounds, and is lashed together in traditional fashion.

I came into the picture in the summer of 1994, during a decade of mass cultural revival for my tribe and many others. I am the first baby born in tradition within our community, and I was fortunate enough to receive a traditional name shortly after I was born. My name was given to me by Cindi's father, Bernie Alvitre, who was an elder in our community. My ties to *Mo'omat Ahiko* and the Ti'at Society were sealed at birth. *Mo'omat Ahiko* is a living sign of our growth as a community, she is our ancestor, and we are all connected to her.

Being a paddler has been a lifelong learning process. One of my earliest memories and the beginning steps of my journey in becoming a paddler started when I stood with my mom and other community members in the Avalon Bay breakwater in 1996, singing during the welcoming ceremony for *Mo'omat Ahiko* as she made her second voyage to Pimu from the mainland. These voyages were monumental for our people because they marked the first time in over two centuries that one of our traditional *ti'ats* had been in the ocean. Even though I was only two years old, being a part of that event was an introduction to the ways in which our community comes together in solidarity to support our paddlers. Without learning how to be a good community member first, I would not have been a paddler. We all rely on one another to function as a community. *Mo'omat Ahiko* has made the voyage to Pimu less than a handful of additional times. Through the years she has been primarily used as a ceremonial vessel.

Before I could enter *Mo'omat Ahiko* and begin practicing, I had to spend a number of years as a junior paddler and learn from everyone. Growing up, I was the youngest in our community, so I was able to grow up with *Mo'omat Ahiko* and watch our community and my position within it develop. At an early age I helped fill up sandbags that would serve as the ballast of the boat. The community also entrusted me with grabbing some of the paddles from the trailer when we would go out to practice or for a ceremony. I would try and help in every little way possible. My cousins, aunties, and uncles who were around all helped foster my interest along the way. As I got older my responsibilities slowly started to grow. Around the age of ten I was able to go out on the water in one of the support kayaks and be there out on the ocean with the paddlers during practice. It was awesome being out there with

everyone and having the opportunity to watch *Mo'omat Ahiko* and the five paddlers glide through the open sea.

After people became aware that I had my sea legs, I graduated up to water bailer and had the opportunity to be in our *ti'at* out at sea. As water bailer it was my duty to sit in the middle of *Mo'omat Ahiko* and bail water while the others paddled. I did this for a couple of practices and got the hang of it. The first time I went out in *Mo'omat Ahiko* for a big ceremony was for the World Festival of Sacred Music in Santa Monica. I remember being really nervous because it was our community's responsibility to take all the offerings that people gave during the festival out to sea and offer them to the ocean.

I vividly remember that occasion being the first time I had gone out really far in water and encountered swells that were several feet high. I know I couldn't be the only one who was nervous, but it exemplifies the trust that everyone has in each other as paddlers and as a community. I was the youngest there, so all I had to do was pump water out of the *ti'at* and help with the offerings. There is no way my mom would let me out there without someone knowing what to do in case something happened. We rely on our captain and one another for safety and guidance; there is a bond among paddlers that is formed by knowing that you're responsible for one another's safety. It was an amazing opportunity to be a part of something so beautiful. I can still recall the choppy breakwater and when we were heading back. The anxiety of something going wrong was overshadowed by the beauty of seeing our community and people from all over dressed in white singing our coming-home song, waiting for us to come ashore.

The World Festival of Sacred Music was my final informal test. In a few years' time everyone saw it fit for me to finally begin to practice paddling. I started paddling when I was around thirteen or fourteen, and the first time I paddled was during one of our practices out in Long Beach. I remember being so excited and nervous at the same time to finally be able to paddle. The paddlers were so nice and understanding even though I was banging their paddle heads and was all out of rhythm my first time. It was a culmination of working and waiting years for my opportunity to paddle. I was finally able to feel the burn in my arms from the weight of the paddle and the warmth of the blood running down my knees from kneeling and attempting to paddle in unison with everyone. It's invigorating being out on the ocean in *Mo'omat Ahiko* and feel the warmth of the sun and salt spray on my face like my ancestors did. It's an honor to be able to paddle and continue a tradition that was gone for so long. I cherish every memory I have of paddling and enjoy

the shared experiences I have had through the years with people from all over. Paddling and being out in the ocean are only small aspects of what it means to be a paddler. Paddling is the culmination of hours of people's time, labor, and effort. *Mo'omat Ahiko* requires maintenance in order to be able to go out on the ocean. It is our commitment to *Mo'omat Ahiko* as a community to keep her in shape to be seaworthy. She is the only vessel we have. As a community we get together to work on her and assist in whatever ways we are capable. That entails getting together nearly every weekend and looking for cracks in her hull, laying epoxy, and making the cordage that binds her together. As she has gotten older, *Mo'omat Ahiko* has felt the wear and tear of being out at sea. It's beautiful to be able to work on her and watch all of our hard work progress and get her in shape. I was lucky that my community took it as their responsibility to help raise me and teach me things the right way. I now can look at *Mo'omat Ahiko* and locate cracks in the planks that need repair and work on her with the love and tenderness that is necessary. I have also begun making my own paddle heads by sanding and shaping them under the instruction of members from the Ti'at Society. So sometime in the near future I will have completed my own paddle.

Mo'omat Ahiko has stayed with several of our community members through the years. She now resides at Cal State Long Beach, where we meet to work on her. *Mo'omat Ahiko* is growing old, and we hope to retire her in the future. As a community we are striving to get a boathouse so it can serve as a space where we can store our *ti'at*, safely work on building others, and strive to pass the knowledge of making *ti'ats* on down to the next generation of paddlers.

Our *ti'at* is the pillar of our community. As one of the youngest paddlers and members of the Ti'at Society, I feel a sense of responsibility to pick up where the generation before me has left off. I know that nothing has been easy and that it has taken years for us to get to where we are as a community and as individuals. This whole process has been one of healing and learning for me. It has given me an opportunity to connect with *Mo'omat Ahiko* on an intimate level and absorb teachings from the elders around me. We have lost so much through time, but the birth of *Mo'omat Ahiko* and all that she has brought to us serve as the beacon of hope and recovery for our community.

I feel fortunate to have such a strong core group of people around me who were willing to invest their time, love, and effort into me. Everyone in my community has played a role in shaping the individual I have become. I feel like it is my duty to honor my mom, as well as all my aunties and uncles

who have helped me grow through the years, by reciprocating all the love that they have shown me to the next generation.

I see our community and others changing and developing rapidly. Change is a natural process of life, although it can be difficult to process. As some of our community members grow old and journey into the spirit world, there is also joy and happiness to be found in the laughter and smiles of the children who will become our next generation of paddlers. It all brings me hope knowing that what my ancestors and community members before me fought for will not disappear, and that young adults have been given the opportunity to continue their legacy. I hope that during my time here on this world I can help in continuing the work that our people never stopped doing by honoring our ancestors and keeping our ceremonies alive. For as long as I live I will always be tied to *Mo'omat Ahiko* and our Ti'at Society. She runs through my veins and is a part of who I am.

Harry Shearer, an iconic L.A. public intellectual for decades, now lives and broadcasts in New Orleans, but his podcast, *Le Show*, had a thirty-year radio run here. As a weekend-drive respite from headline-news programs, *Le Show* combined Shearer's angry commentary, satiric sketches, readings of incendiary or just dumb print journalism, and "feed" clips—audio grabbed from satellites, basically outtakes from space. Less well known is his weekly *L.A. Times Magazine* column in the early 1990s called "Man Bites Town." The concise pieces, such as the two included here, reflect Shearer's broad knowledge and observational acumen. In the first selection, "What's That Smell?," on the disappearance of smells in the city, he summons the ghost of a bread factory in Beverly Hills that will haunt old-timers who might also remember the Van Nuys GM assembly line, the DTLA Coca-Cola bottling factory, and other bygone repositories of "good middle-class jobs." In "The Age of Minimallism," he nails an intersectional (in all ways) moment when a changing economy meets the street.

AND NOW THIS

TWO BITS

135

MAN BITES TOWN

HARRY SHEARER

WHAT'S THAT SMELL?

The stereotype of L.A. isn't big enough. Nobody's is—that's the whole point of stereotypes. If you wanted to know more than a stereotype tells you, you'd have to read a book or something. So this city's clichés have stopped well short of, for example, the crows. Ask a TV viewer in Chicago what L.A. is famous for, and he would probably not say, "the crows." Yet, for anyone growing up here, there's a recurring memory of the crows, yakking it up on lazy summer afternoons (lazy for me; the crows seemed plenty busy).

Hardier than many landmark buildings, they are with us still today.

The only smell that Los Angeles is noted for is the vague aroma of unbreathability on high-ozone days. But in the recent past, the local geography was dotted with smells. There was a dairy farm on La Cienega. There were bakeries, known to noses for miles around, like the Helms plant on West Venice, now a coalition of furniture showrooms. And, ironically, better-smelling yet, there was a Wonder Bread bakery in Beverly Hills.

Wonder Bread and Beverly Hills—those words don't even seem to exist in the same language. Wouldn't the city fathers of our world-class poshopolis have insisted that, if you're going to bake anything within the city limits, it's going to be croissants and baguettes (maybe some corn rye at night)? But for years, the drive along Santa Monica Boulevard was accessorized with the best

part of corporate white bread: the smell of it baking.

Amiable aromas were the occasional fringe benefits of having manufacturing facilities inside American cities. No one who drove into San Francisco until very recently could ignore that city's salute to the schnoz: the smell of coffee being roasted at a large downtown shipper next to the freeway. There is a Chicago neighborhood that for years nestled beneath the sweet haze coming from the chocolate factory at its center.

Sure, manufacturing put out more than its share of foul odors. The factories that turn out brown-paper bags stink like a Kansas City slaughterhouse on a bad day in August. Maybe this is one of the charms of life that is never so charming until it disappears, but the smell of good stuff being made was a definite attraction of city life.

Those city smells are fast disappearing, if not already long gone. The American economy has assigned the making of things to other corners of the world. They don't roast coffee on a large scale in San Francisco anymore; has the whole business been centralized somewhere in Michiana?

Advances in refrigeration and transport, and the takeover of big regional food companies by huge national food companies, which in turn got bought by mammoth, cash-rich tobacco companies, have led to the Ghirardelli Squaring of the old in-town factories. The only smells coming from the old Jackson Brewery in New Orleans these days are those of perfumed candles and the odd fragrance you detect when large amounts of new clothing are being sold under one roof.

It's possible that air-pollution rules are wiping out some of the smells. After all, there are boutique bakeries and boutique breweries, but if you didn't know they were there, your nose wouldn't tell you. It could be that the aromatic gases escaping from those ovens and roasters were as bad for us as the smoky effluent of the charcoal grills and the dangerous pungency of dry cleaning in action. But the less attractive odors are still with us. Anyone driving the San Diego Freeway past refinery row knows that.

The things that most of us spend our working days doing just don't—with the exception of show business—declare themselves to the public nostrils. Perfuming the city, like creating jobs, is a task that's been left to the retail level. Restaurants, *pupuserías*, leather stores, beauty salons—who can resist the cantata of hair sprays wafting out the door? Bars still send out their aromatic advisory that brains are being marinated within.

Ultimately, we are lucky enough to have two natural sources of city

fragrance that have made it into the lore: the ocean, whose briny call occasionally penetrates east of Sepulveda, and the desert. Sometimes, on one of those special nights when the Santa Anas are blowing just right, you can stand 100 miles southwest of the desert and take a deep draft of air that smells of wildflowers and chaparral.

It's pretty spectacular. You'd swear they were baking Wonder Bread up there.

THE AGE OF MINIMALLISM

There are certain words that, if spoken from the stage of a comedy club, are almost Pavlovian for laughter: airlines, TV commercials, 7-Elevens, traffic, minimalls. Aside from "Hey, how ya doin'?" the most predictable phrase uttered into a microphone in front of a plain brick wall these days is "Can you believe these minimalls?"

The word itself is comedically perfect because it is just as ugly as the thing it describes. In addition, it's a fine word to say. The way it runs from the lips to the tongue and back again makes it just about the most fun your mouth can have pronouncing a word without a k.

Complaining about minimalls—sharing the horror at the way these dandelions of commerce pop up—is also one of the few experiences that truly brings Southern Californians together.

And yet, and yet...there are things to be said in praise of minimalls. To begin with, they're ours. For reasons best known to real estate developers, this particular system of grouping businesses is more common in Los Angeles than in any other major city. The lower-than-normal rents of these quaintly named mock plazas serve as an entry point for immigrants into the world of retail. And since the advent of these structures, L.A.'s women have probably never had better-looking nails.

But the biggest contribution minimalls have made to our community is, in fact, their general ugliness. The garish colors, the bargain-basement borrowing of the most obvious clichés of postmodern building decoration—it has all been worthwhile because, like the junior-high prankster, it makes us look.

Minimalls have been our Introduction to Architecture.

Aside from the rare residential masterpiece tucked away in a canyon and the self-promoting glass boxes of our many fine downtowns, we have lived in a city without Architecture. Structures were either so outrageously amusing (the giant doughnut, the giant hot dog, the giant ice cream cone) that they

seemed to be pieces of a cartoon landscape come to life, or they were so plainly functional that they slipped right past any attempt to notice them.

That sort of unaggressive unattractiveness was characteristic of the gas stations that, in so many cases, minimalls replaced. Yes, a Unocal station in Beverly Hills has a modernistic swooping wing, and Chevron had a couple of tile-and-adobe gasoline cottages on Pacific Coast Highway. Otherwise, gas stations weren't so much designed as assembled from a catalogue of standard (or Shell) equipment: pumps, canopies, driveways, lube rooms, offices, bathrooms. You weren't supposed to notice anything about them except the big trademark sign in front or, in the case of an off-brand station, the prices.

In short, we have been living in Stage One of human settlement: Man clears the brush and erects simple structures in which basic needs are met. The minimalls mark our bittersweet journey into Stage Two: Forget about the mountains and the trees; look at the buildings. Gaze, if you will, upon the glass pyramids of Olymp-Arado Square.

We've started to look, and with the few exceptions at certain influential intersections, we don't like what we see. Not coincidentally, we're noticing other things. We're beginning to cherish, as they disappear, the wacky little car washes and coffee shops that were the occasional decorative punctuations at the end of our functional days. And we're beginning to appreciate the few undemolished movie palaces that are still among us.

Every new pile of neon-encrusted stores with pastel banisters creates in its wake a new node of neighborhood activism, groups sworn to keep their eyes open to prevent similar disasters from ever happening again. Once opened, those eyes will—like the twenty-four-hour coffee shops of the '50s—never close. When Stage Three—it's called Important Architecture—arrives, a city full of critical watchers will be waiting. In the meantime, Stage Two has also introduced us to the idea of recycling first-growth buildings: warehouses reborn as lofts, railroad stations retrofitted as seafood grills. It's a familiar pattern in older cities. Here, it's an impulse just beginning to compete with "Aw, hell, tear it down and start over."

Recycling will become a way of life, as those vigilant neighbors make it increasingly hard to tear anything down. The man who wants to replace La Neona Plaza with something Important will have a hell of a fight on his hands. And in thirty years, when we're all flying in and out of Palmdale, the Delta terminal at LAX will probably have been transformed into Excess Baggage, a huge and hip new eatery.

Untitled #11 (Nowhere), 2012

NOWHERE
ALEXANDRA HEDISON

My artistic work focuses on stories of transition. I'm drawn to the "in between," a theoretical state bounded by two positions, one known and the other unknown. My photographs attempt to address this space between identifiable points—the waypoints that are neither here nor there. These images from *Everybody Knows This Is Nowhere* delve into stories both personal and projected that are associated with familiar places.

Our personal narratives are constantly shifting. We adapt and curate them, bringing attention to certain aspects and forgetting other details that may be just as relevant. Thinking about my past, I realized that I needed to return to the place that held my first conscious impressions. I wanted to understand how I've constructed my own story and how that story has changed over time.

I grew up in Malibu, where the beach houses were built on piling foundations to withstand storms and shifting tides. Returning to that landscape in 2008, I wanted to actively participate in the process of composing and editing my own narrative. Initially I started shooting during the stormy months in winter. I focused on the underbelly of the beach houses and how the tides altered the levels of the sand from season to season.

To experiment with this idea of "storytelling," I considered the unfixed perspective of the storyteller. I shot from the same position on the beach at different times of the day and then, eventually, from season to season. Many cameras were used—from my father's 1960 manual Nikon to various medium-format film and digital cameras—to create a series of images associated with my memories. This process, piecing together my story by examining multiple perspectives, spanned the course of four years.

By 2011, I had produced masses of photographs that were all similar and yet entirely different. The landscape had altered from month to month, and each lens told a different story. Composites were made by overlaying these images—bringing certain ones into focus and leaving others to fade away. Memory in the form of photographs becomes an amalgamation of repeated ideas; single frames join together to form one image.

—A.H.

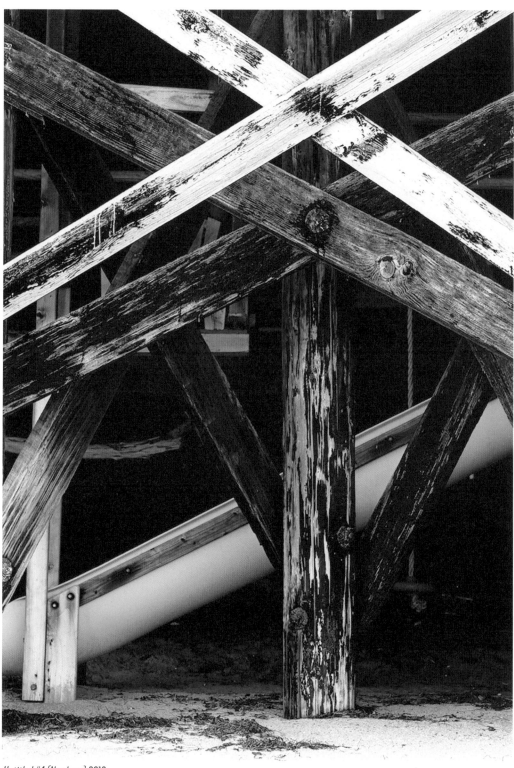

Untitled #4 (Nowhere), 2012

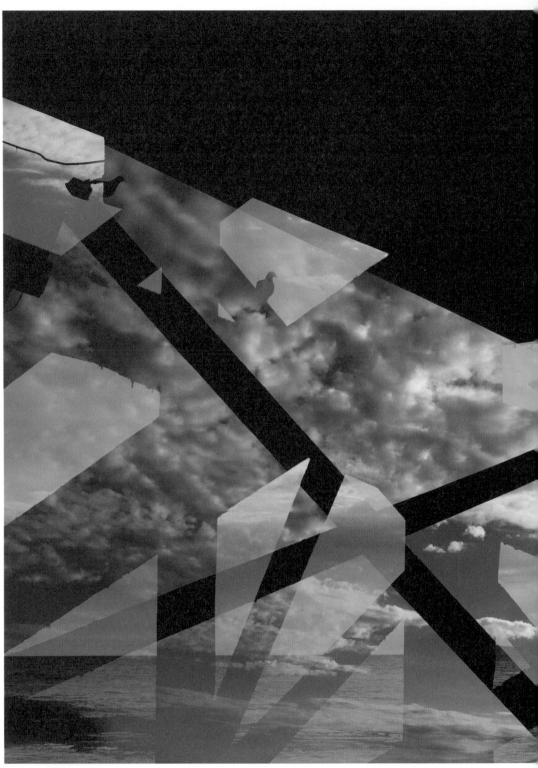

Untitled #34 (Nowhere), 2012

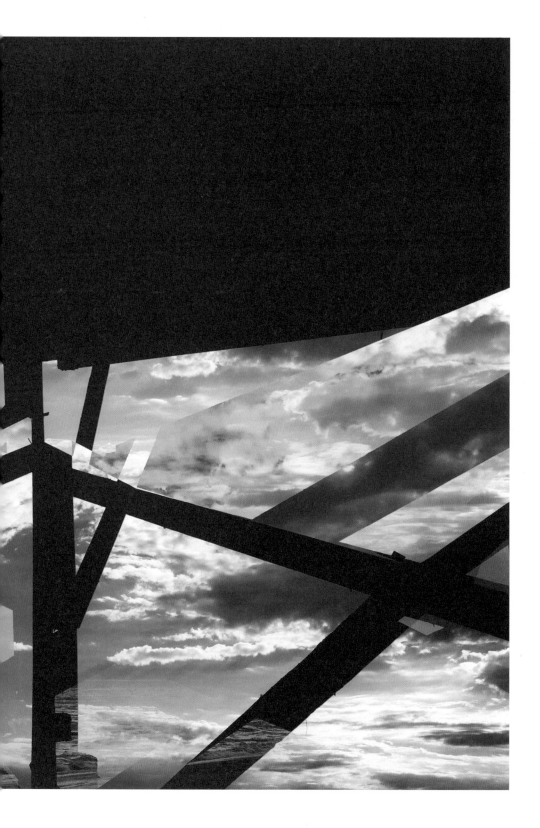

Untitled #6 (Nowhere), 2012

Untitled #3 (Nowhere), 2012

Untitled #10 (Nowhere), 2012

Untitled #8 (Nowhere), 2012

Twenty years after its publication, *Tropic of Orange* may come to readers with an accumulated layer of academic-critical interpretation and online reviews. But taken fresh, without a pondering of the seven (!) subcategories of fiction with which it's tagged by Wikipedia, the novel seems pretty homey and real. And it's one of those books whose storylines are, for many of us, more easily followed on a second reading. Maybe that's because the vision of the city Karen Tei Yamashita presents is of an enormous, malleable, porous membrane that stretches across continents, almost to a snapping point. Her many-walks-of-life characters and their lives and their actions are contained within, as are the lives of millions of others. This selection follows a single character, the homeless conductor named Manzanar, through several phases of the story, told by several narrators. It gives a taste of the heady accumulation of everyday apocalyptic detail to be gulped or savored. If there's such a thing as accurate imagining, Yamashita is a master of it.

SET TO MUSIC 4 SCENES

TROPIC OF ORANGE

KAREN TEI YAMASHITA

"8: RIDESHARE – DOWNTOWN INTERCHANGE"

Manzanar lifted and dipped his baton, feeling his way carefully through the early morning traffic. It was a red convertible Porsche. The two young men wended their way north toward Hollywood, peeling oranges, bouncing flippant ideas for a storyboard back and forth. It was overcast but so what; the forecast was always sun. Not that Manzanar knew; he was just a conductor. The terrible pain of this moment flashed: the screech of tires, the groaning wail of the monstrous semi pulling 40,000 pounds of liquid propane under pressure in its shiny stainless-steel interior—its great twisting second-half tumbling and thundering over itself, and the horror in the face of the driver who knew the consequences of this payload. All this played against the metallic crash and crunch of the unfortunate who shared the same lanes, the snap of delicate necks, the squish of flesh and blood. In both directions of the freeway, spread across ten lanes, hundreds of cars piled one onto the other in an almost endless jam of shrieking notes. Perhaps, perhaps someone had caught it all on video. There was always someone out there catching unsightly things on video. Perhaps not. In any case, Manzanar had fearlessly recorded everything—every horrible, terrifying thing—in music. The sad refrain, not meant to be insipid, was the gentle notes of ridesharing. He had seen the friendship of the two young, and indeed beautiful, men,

their brief encounter with happiness, and the possibility of success.

Ridesharing, when it was practiced in greater proportions, alleviated flow, increased rhythm while enhancing and deepening tone. Manzanar, for one, was grateful. The complexity of human adventure over lines of transit fascinated him. The mass of people flowing to work and play, the activity of minds muddling over current affairs, love affairs, the absence of affairs, in automatic, toward destinations beyond streets, parking lots, or driveways: Manzanar followed it all conscientiously.

Long ago, Manzanar had been a skilled surgeon. His work had entailed careful incisions through layers of living tissue, excising tumors, inserting implants, facilitating transplants. At what point the baton replaced the knife, he could no longer remember. Perhaps the skill had never left his fingers, but the will had. He could as easily have translated his talents to that of a sculptor in clay, wood, or even marble—any sort of inanimate substance, but strangely it was the abstraction of music that engulfed his being. One day, he left a resident to sew up a patient, removed his mask, gloves, and gown, strode through the maze of corridors, down the elevator, through patient waiting, to become a statistic under missing persons.

Manzanar imagined himself a kind of recycler. After all, he, like other homeless in the city, was a recycler of the last rung. The homeless were the insects and scavengers of society, feeding on leftovers, living in residue, collecting refuse, carting it this way and that for pennies. In the same manner, who would use the residue of sounds in the city if Manzanar did not? This was perhaps a simplistic interpretation of his work, as simplistic as, for example, the description of his utilizing the sounds of cars whooshing down freeways to imitate the sound of the ocean. Poetic, but false. Everything had its own sound. Genius disguised, as always, with innocent simplicity.

There are maps and there are maps and there are maps. The uncanny thing was that he could see all of them at once, filter some, pick them out like transparent windows and place them even delicately and consecutively in a complex grid of pattern, spatial discernment, body politic. Although one might have thought this capacity to see was different from a musical one, it was really one and the same. For each of the maps was a layer of music, a clef, an instrument, a musical instruction, a change of measure, a coda.

But what were these mapping layers? For Manzanar they began within the very geology of the land, the artesian rivers running beneath the surface, connected and divergent, shifting and swelling. There was the complex

and normally silent web of faults—cracking like mud flats baking under a desert sun, like the crevices in aging hands and faces. Yet, below the surface, there was the man-made grid of civil utilities: Southern California pipelines of natural gas; the unnatural waterways of the Los Angeles Department of Water and Power and the great dank tunnels of sewage; the cascades of poisonous effluents surging from rain-washed streets into the Santa Monica Bay; electric currents racing voltage into the open watts of millions of hungry energy-efficient appliances; telephone cables, cable TV, fiber optics, computer networks.

On the surface, the complexity of layers should drown an ordinary person, but ordinary persons never bother to notice, never bother to notice the prehistoric grid of plant and fauna and human behavior, nor the historic grid of land usage and property, the great overlays of transport—sidewalks, bicycle paths, roads, freeways, systems of transit both ground and air, a thousand natural and man-made divisions, variations both dynamic and stagnant, patterns and connections by every conceivable definition from the distribution of wealth to race, from patterns of climate to the curious blueprint of the skies.

As far as Manzanar was concerned, it was all there. A great city of maps, musical maps, spread in visible and audible layers—each selected sometimes purposefully, sometimes at whim, to create the great mind of music. To the outside observer, it was a lonely business; it would seem that he was at once orchestra and audience. Or was he indeed? Unknown to anyone, a man walking across the overpass at that very hour innocently hummed the recurrent melody of the adagio.

"17. THE INTERVIEW – MANZANAR"

Like Buzzworm promised, I got my interview with the homeless conductor. We met around Pershing Square and tried to get comfortable on one of those curved bus benches that won't support a sleeping homeless person. I passed out the McMuffins and the coffee and tried to be inconspicuous while Buzzworm did the interview. This was my understated pretense until the end when this homeless character looked me in the eyes and said, "Since you haven't taken any notes, I'm assuming you're taping this."

"Why no. I'm not."

Buzzworm smiled. "Don't worry. He's good," he assured the man. "Has an almost audiographic memory." And before I could protest, Buzzworm

made further assurances: "Besides, guaranteed you see the copy before it goes to press. Right Balboa?"

Audiographic memory. I could have strangled Buzzworm on the spot. Pretty soon, he'd want every homeless person in L.A. to verify my quotes and critique the copy.

"It's about trust, Balboa," Buzzworm tried to justify. "And respect."

"The President of the United States doesn't get this privilege, goddammit!"

"You weren't interviewing the President. You were interviewing Manzanar Murakami, the first sansei born in captivity. Did you hear that?"

"He's crazy."

"That's what you gonna write?"

"No." Buzzworm was right. There was something important about this man, so wise, so completely honest. He deserved my respect. He probably did deserve to see my copy as well. It wasn't going to be easy. For the moment I couldn't see any way to do justice to the story. He might just look like one more crackpot homeless figure who got stepped on by the system. But this was a case where the man had sidestepped the system. And there I was without a pen or an audio recorder, without words.

I hurried back to my desk, tried to reconstruct the interview, reorganize Buzzworm's circuitous style. It drove me nuts. I was always the hunter, calculating my moves, getting ready for the kill. Of course, finesse was involved; I was subtly brutal. I'd be out of there before anyone remembered what happened.

But Buzzworm played the interview like a social soccer game, moving in, dancing with the ball, a foil there, sparring, dribbling the thing around to no obvious purpose. Or he was editorializing for my benefit with upstart questions like: "When you're conducting and look up at these downtown skyscrapers, maybe one-third of them empty, as somebody homeless, what do you think?" or "You ever come to make the connection between the fall of the Berlin Wall and the rise in homelessness in L.A.? Some think if we gotta blame someone, it still oughta be the Russians." or "Most everyone on the street's got a conspiracy theory. What's yours?"

Still I had to admit that when Buzzworm finally nailed the goal, it caught me by surprise.

"So you been out on the streets how many years?"

"You composing your own stuff or what?"

"How come you never use my services?"

"What did you do before you moved to the streets?"

"How about jazz? Coltrane? Miles Davis?"

"Where were you born?"

"You come from a musical family?"

"You ever been seen for psychiatric care?"

"What about Bach? Mozart? Dvorak?"

"What did you eat today?"

"How old are you?"

"When did you graduate UCLA?"

"How's your eyesight? Sure you don't require some eyeglasses?"

"Where do you camp out?"

"What hospital did you work in?"

"How about your folks?"

"If you could get a job, then what?"

"Maybe you should get yourself a partner."

"What about medication or drugs?"

"You play an instrument?"

"What kind of surgery did you do? Anybody ever die?"

"How's your general health? How about the bowels?"

"Now, I know you're conducting, but how's it work? I mean, what's going on when you're out there?"

"How you making out? You picking up welfare?"

"Is that your real name?"

"You're an educated man; you don't consider that you might be crazy?"

Manzanar Murakami did not consider himself to be crazy. I had read about cases of schizophrenia where people could be completely convincing in various roles. It was not his real name, so perhaps he had never been a surgeon, never graduated UCLA. Perhaps it had been one of his former roles. I couldn't be sure. He had created his name out of his birthplace, Manzanar Concentration Camp in the Owens Valley. He claimed he was born there during the war. That would have been over fifty years ago, and he looked to be well over fifty.

He had smiled wryly under a bush of white unkempt hair that he must shear off himself from time to time by simply grabbing it on top and hacking. His clothing was worn but not tattered. Even in the heat of June, he wore a black trench coat—good quality with a lot of pockets and zippers just like Buzzworm said; like other homeless, he carried all his belongings on his

person. Said he had a "modest place" in an encampment hidden in freeway overgrowth; Buzzworm knew the place. The man had a blackened appearance like a chimney sweep. Like the underbelly of the overpass itself, it seemed rather permanent. Beneath this sooty exterior, however, I noticed a powerful body, broad chest, and strong arms, as if the man worked out. What a lousy baton could do for the body! There was something of the stevedore about him. The elements of the urban outdoors had not worn him down, yet. I imagined he could simply take a shower, don a white jacket, and be transformed very suddenly into Dr. Murakami.

What struck me was that Manzanar was probably not crazy. There was a subtle quality about him and an honest reticence that seemed to reflect a true kind of modesty. He had a clarity of mind and speech; no glitches that I could notice. But then, who am I to say? After all, he lived on the street; he conducted an orchestra no one could see and music no one could hear. But his attitude was monkish, like a character in a Kurosawa film who shaves his head and forsakes all worldliness—a kind of head start toward nirvana. And yet he was funny. His words and manner were laced with irony and intelligent humor. I figured if he were crazy, a lack of humor would be a dead giveaway.

Buzzworm had no opinion about this. It didn't matter if he were out of his mind. Look at Buzzworm. He was crazy. So what? Still, it wasn't your typical homeless story, if there were such a thing. It could be said that Manzanar had chosen homelessness as a way of life. This probably wasn't the message Buzzworm was trying to convey. Buzzworm was trying to get jobs, housing, health care, rehab, and mental services for the folks. Manzanar wasn't exactly a case for any of these things, but Buzzworm said, "Balboa, forget the social agenda. Just tell the story. Point is there's people out here. Life out here."

One final thing struck me; it was that there was something I had to learn from this man, something I needed him to impart to me, not as the subject of an interview or an investigation, but something he could teach me, as if he were some sort of conducting shaman, as if he held a great secret, as if he knew the way. Of course I couldn't admit this to Buzzworm; it was purely absurd. I was the journalist of current events, hellbent on getting the story out. Still, not knowing this secret would only mean that Manzanar would continue to be just another crazy old man.

I didn't make the Asian connection until I got Emi's habitual afternoon call; but then why should I connect Emi to Asianness? Maybe Emi never let me forget I was Chicano, but it was easy to lose track of Emi. She defied

definition. "Ever heard of Manzanar Murakami?" I asked. "He's sansei," I added, as if it would help.

"Oh-kay," she said, like she was dealing with a hypothesis of some sort.

"He's homeless."

"Do I know anybody homeless?"

"Do you know anything about your community at all?"

"Gosh, what do you figure, Gabe? Twenty thousand of us? Fifty? A hundred? I'm supposed to know one homeless Asian?"

"Your people take care of each other. This guy is very noticeable. I bet someone's noticed him. I bet your mom's heard of him."

"True. My mom reads the *Rafu* cover to cover. Too bad you don't write for the *Rafu*. That would really impress her."

"She likes me anyway."

"But she doesn't read your stuff much. *Rafu*'s got the J.A. obits. She never misses a funeral. Do you know what *koden* is?"

"No."

"Well, she's spent a fortune on it."

"Ask her about Manzanar Murakami, will you?"

"What kind of name is that?"

"Sansei hybrid."

Emi changed the subject. "Now I know all of you over there only get your news from printed matter, but did you at least hear the second semi blow? They can't contain the fire. Don't you get out? It's got to be smoking your way. Even imprisoned behind four inches of glass, you must have heard the blast."

"I thought they cleared it up. That was yesterday."

"How did you get to work?"

"I had an interview six a.m. I took side streets to pick up coffee. Wait. You said second semi. There's more than one?"

"Where have you been? Turns out a second semi—no apparent relation to the first—knifed a few minutes later about a mile back of the first. This time, it was just ten thousand gallons of sloshing gasoline. One more giant Molotov cocktail on wheels. Besides which, a truck crashed into the second semi, spilling thirty-three thousand pounds of meat. That's when the whole thing blew up. It's dead cows all over the freeway. Can you imagine the barbecue? An entire mile of cars trapped between two dead semis, not to mention two craters, fires, and the debris from the blasts. Find a TV for godssake! There's a very weird view from the NewsNow copter. Cars on fire,

all the ivy, palm trees, brush, signs. Worse yet, the Santa Anas are blowing through like the one-ten was a canyon in Malibu."

"There's a homeless encampment in the overgrowth around there."

"It's not Malibu. It's gonna burn."

"I gotta go." I hung up and paged Buzzworm.

"Cardboard ramshackles've gone up in smoke," he reported. "You believe there's maybe two-three hundred of 'em live up in here?"

"Where're they now?"

"They're headed down onto the freeway."

"What?"

"Traffic's at a standstill. Folks abandoned their cars. Explosions, fires. You'd run for it too. Some didn't make it. Homeless're in the cars now."

"Buzz, whaddya hear on your radio?"

"Sports."

"What happened to the news?"

"Balboa, ain't we got enough news yet?"

"Give me fifteen. I'll be there." I paused and decided to ask while I remembered, "Buzz, at the interview this morning, what were you tuned to?"

"You mean what was I on?"

"Yeah."

"Just talk."

"Howard Stern?"

"What I be listening to New York for?"

I thought about this. "Rush Limbaugh?"

"Listen, Balboa. I take it all in. KFI, KLSX. Might as well be KLAN as in Ku Klux. People out there starved to talk, try their excuses for brains out on the airwaves."

"Yeah," I agreed, but I was gonna miss the homeless taking over the one-ten. I hurried on like the reporter I am. "We'll talk more. See you in fifteen."

"Balboa," he stopped me. "The C. Juárez thing? I got some addresses for you, but they all lead south, meaning maybe Mexico. And I think you're right. It's not just about illegal medication. Cartel's into diversification."

"Damn," I said.

"There's always a price attached to these addresses. Can you pay up?"

"Depends."

"Looks like it's not a monetary price. More like a political one. They figure a journalist like you has connections, see."

"I'm listening."

"They insist on a meeting. Mexico City. Need to size you up to make an offer, I guess."

"You guess! I can't be everywhere," I complained.

"It's your call. I myself don't go nowhere. Hell, L.A. don't go nowhere, and look at this. Shit just comes to us."

I didn't say anything. I was being lectured to again.

"About Manzanar. You wanted to know?"

"Right."

"SigAlerts and weather. Commuter Classics. Was I wrong?"

"I guess not." I hung up and grabbed a Power Bar from the top desk drawer, washed the chewy consistency down with a gulp from my mug of always-cold coffee. I paused over the mug's significance. Emi had given it to me. An eyeball floated by means of a ceramic post in the middle of the black liquid—a mercurial gray under these artificial lights. With the smoke rising from the freeway fire out there, the eyeball was looking like the sun in my L.A. pewter skies. The mug read sardonically, "Here's looking at you..."

"19: HOUR OF THE TRUCKS – THE FREEWAY CANYON"

Manzanar concentrated on a noise that sounded like a mix of an elephant and the wail of a whale, concentrating until it moaned through the downtown canyons, shuddered past the on-ramps, and echoed up and down the 110. There was an instinctual recognition of this noise by those who could hear it. The salutary marching orchestral backdrop à la Yojimbo/Atom Boy hinted at the original *Godzilla* theme. It was slightly cartoonish, and the timing was purposely out of sync, as if the entire thing—even Godzilla's wail— were dubbed. This was *The Hour of the Trucks*, which Manzanar conceived of in his strangely organic vision, appropriate if one were to compare the beastly size of semis, garbage trucks, moving vans, and concrete mixers to the largest monsters of the animal kingdom—living and extinct, all rumbling ponderously along the freeway.

Manzanar knew the frustration of the ordinary motorist wedged between trucks—the nauseous flush of diesel exhaust and interrupted visibility— but he also understood the nature of the truck beast, whose purpose was to transport the great products of civilization: home and office appliances, steel beams and turbines, fruits, vegetables, meats, and grain, Coca-Cola and

Sparkletts, Hollywood sets, this fall's fashions, military hardware, gasoline, concrete, and garbage. Nothing was more or less important. And it was all moving here and there, back and forth, from the harbor to the train station to the highway to the warehouse to the airport to the docking station to the factory to the dump site.

The slain semis with their great stainless-steel tanks had sprawled across five lanes, bleeding precious fuel over the asphalt. The smaller vehicles of the automotive kingdom gawked with a certain reverence or huddled near, impatiently awaiting a resolution. Police cars and motorcycles, followed by ambulances and fire trucks, sirened and blinked meandering and treacherous paths between lanes and over shoulders to the sites. Helicopters hovered, swooping in occasionally for a closer shot, a giant vortex of scavengers. The great land-roving semis lay immobile, dwarfing everything—even the formidable red fire trucks, poising themselves defensively around the victims.

When the tanks blew and the great walls of flames flew up the brush and ivy along the freeway canyon, Manzanar knew instinctively the consequences, knew that his humble encampment wedged against a retaining wall and hidden in oleander would soon be a pile of ash. To leave his perch and abandon his music to save his home would be a useless and dangerous enterprise. Anything of personal value he carried in one of his numerous pockets. He would lose some books, magazines, a lantern, cooking utensils, bedding, a change of clothing, soap. For those who had nothing, this was everything.

Manzanar continued to conduct, watching the fire engulf the slope. Even he, who knew the dense hidden community living on the no-man's-land of public property, was surprised by the numbers of people who descended the slopes. Men, women, and children, their dogs and even cats, bedding, and caches of cans and bottles in great green garbage sacks and shopping carts moved into public view, sidling along the lines of abandoned cars, gawking into windows and kicking tires, remarking on the models, ages, and colors, as if at a great used car dealership. From Manzanar's perspective, and given its length of one mile, it was the greatest used car dealership.

The vans and camper trailers went first; then the gas guzzlers—oversized Cadillacs with their spacious pink and red vinyl interiors, and blue Buicks. A sleek white limousine with black interior was in particular favor. A spacious interior with storage space was favored, while the exterior condition of a car was deemed of secondary importance. Never mind the Bondo sanding projects in the works, a falling muffler, or the crushed brake light patched

with red plastic. Boxy Volvos and Mercedes, and Taurus station wagons, had the advantages of space and sturdy structure. Some wondered if good tires weren't a necessity. Compacts were more popular than two-seater sports cars. Porches, Corvettes, Jaguars, and Miatas were suddenly relegated to the status of sitting or powder rooms or even telephone booths (those having cellular phones). Convertibles remained as before: toys. Children clambered over them; adults sat in them and laughed.

In a matter of minutes, life filled a vacuum, reorganizing itself in predictable and unpredictable ways. Occasional disputes over claims to territory arose, but for the moment, there were more than sufficient vehicles to accommodate this game of musical chairs. Indeed it was a game, a fortunate lottery, and for the transient, understandably impermanent and immediate. Besides, great walls of fire raged at both ends. What to do now? What to do next? Kids lined up next to a black Beemer with smoked windows to call a 1-800 *How Am I Driving?* number. A commissary truck opened for business, as did a recycling truck. A moving van was emptied of its contents: washing machines, refrigerators, ovens, chairs, tables, sofas, beds, carpets, barbecue pits, lawn mowers, etc. Watermelons, bananas, and cantaloupes were hauled off one truck, as were Wonder Bread, Cacique tortillas, and Trader Joe's fresh pasta. Someone passed out bottles of Tejava and Snapple. Cases of cold Perrier were taken to the fiery front.

A scattered chorus of car alarms honked and beeped. Why in God's name anyone should evacuate a car on a freeway and trigger the alarm one could only speculate; the decision had been made by at least a dozen motorists. The variety and frequency of these car alarms fascinated Manzanar, who accommodated them in his score with appropriate irony. These sounds joined the thudder of helicopters, the sirens of fire trucks, the commentary of newscasters, the opening and slamming of car doors, hoods, trunks, and glove compartments, and the general chatter of festive shopping and looting. It was one of those happy riots. Manzanar wondered if the storming of the Bastille could not be compared to the storming of this mile-long abandoned car lot. Perhaps not.

The Hour of the Trucks was an hour outside of the general rush, but it created its own intensity. In this case, it was quite a mess. As the semis went up in flames, there were the usual questions of traffic safety, whether trucks should be confined to operation during the hours between midnight and dawn or to truck-only corridors. As the homeless flocked onto the freeway,

there were also the usual questions of shelter and jobs, drug rehabilitation, and the closing of mental health facilities. And as car owners watched on TV sets or from the edges of the freeway canyon, there were the usual questions of police protection, insurance coverage, and acts of God. The average citizen viewed these events and felt overwhelmed with the problems, felt sympathy, or anger and impotence. There was also an imminent collective sense of immediate live real-time action, better than live sports whose results—one or another team's demise—were predictable, and better than CNN whose wars were in foreign countries with names nobody could truly pronounce. Of course everyone remembered the last time they had gathered on freeways to watch a spectacle; white Broncos had since become the vehicle of choice. Not surprisingly, the CHP and Triple A together reported at least a dozen instances of white Broncos driven to some finality: E on the gas tank, over a Malibu cliff, to Terminal Island, etc.

Manzanar pressed on through the spectacle that the present circumstances would soon become, the chatter of silly and profound commentary, the cruel jokes, and the utterly violent assumption underlying everything: that the homeless were expendable, that citizens had a right to protect their property with firearms, and that fire, regardless of whether it was in your fireplace or TV set or whether you clutched a can of beer or fingered a glass of Chardonnay, was mesmerizing. All of these elements shifted bizarrely through the movement barely controllable by Manzanar's deft style. Sweat poured from his brow, spattered from the tips of his white mane. Fear rose to his throat, clutching terribly. For the first time, he considered abandoning his effort as he had once abandoned his surgical practice, and yet an uncanny sense of the elasticity of the moment, of time and space, forced his hands and arms to continue. He was facing south on his overpass podium, and he knew the entire event was being moved, stretched. And he was quite sure that the direction was south. Yes, south, for the time being.

Sunrise at Watts Towers. Los Angeles, 2013.

PHOTO BY WARREN HILL

L.A. City Hall was lit up with warm golden light to honor Jonathan Gold's memory, a gesture appreciated by the countless Angelenos who identify as not-fancy-but-discerning when it comes to food and drink. Gold spoke to the many who took to eating in restaurants, cafés, and on the street as a way to be in the city with other people, a way to explore the city and get to know its neighborhoods. Gold was the only food writer in a generation of excellent American food writers who worked the experience of eating out as exuberantly as great cooks work the experience of messing around with ingredients. The admiration he earned wasn't about writing with style—though Gold surely did that—or about his ability to eat with his brain and his mouth. It was about his interest in people and culture, in what he called the real L.A.—and his respect for every one of those cultures that form a piece of the L.A. mosaic. With masterful technique and sharp humor, he spread that respect all around town and the world. This selection is his introduction to *Counter Intelligence: Where to Eat in the Real Los Angeles*, the 2000 book that collected his best *L.A. Weekly* reviews.

MAN ABOUT TOWN
THE GOODS

COUNTER INTELLIGENCE: WHERE TO EAT IN THE REAL LOS ANGELES

JONATHAN GOLD

FOR A WHILE IN MY EARLY TWENTIES, MY ONLY CLEARLY
articulated ambition was to eat at least once at every restaurant on Pico
Boulevard, starting with the fried yucca dish served at a *pupusería* near
where the street began in downtown Los Angeles and working methodically
westward toward the chili fries at Tom's #5 near the beach. It seemed a
reasonable enough alternative to graduate school at the time.

After I'd finished work each day proofreading galleys at a legal newspaper
near City Hall, I would walk to the next restaurant on Pico for dinner. Then
I would buy an orange from a street vendor and catch a bus the rest of the
way home—I lived on Pico too, over a kosher butcher shop near Robertson.
When the enormity of the adventure seemed overwhelming, I might buy
a taco at one restaurant, a hamburger at the next, and a bowl of *chilate y
nuegado* at a third. I ate my way almost to Century City that year, from the El
Salvador Cafe all the way to the old Roxbury Pharmacy grill.

I discovered the Persian-Jewish neighborhood around Beverly, the
remarkable soup of soul food restaurants between La Brea and Fairfax, the
pan-ethnic zone around Westwood. I ate at Pico restaurants—Mr. Coleslaw
Burger, the carnitas place on the corner of Vermont with old boxing snapshots
on the walls, NuWay, Chicken Georgia, Ben's Place, Kong Joo Goat Soup,
Carl's Barbecue—that have since vanished, leaving no traces more obvious

166

than a shiny patch of sidewalk or the ghost of a painted sign. I especially liked the neighborhood, mostly Central American, that had sprung up between Vermont and the Harbor Freeway, thousands upon thousands of Guatemalans and Salvadorans who crowded Pico until dark, choosing toys from big displays set up in grocery-store parking lots, buying mayonnaise-smeared ears of corn from street-corner pushcarts. The restaurants in that neighborhood were good, too, and I learned to eat everything from marinated octopus—at El Pulpo Loco—to the griddle-baked Salvadoran corn cakes called *pupusas*, from El Parian's Jalisco-style goat stew to El Nica's giant Nicaraguan tamales, from Cuban fried rice to Guatemalan *pepián* to the Ecuadoran mashed potato fritters called *llapingachos*.

This was not my mother's cooking. Pico, in a certain sense, was where I learned to eat. I also saw my first punk-rock show on Pico, was shot at, fell in love, bowled a 164, witnessed a knife fight, took cello lessons, raised chickens, ate Oki Dogs, and heard X, Ice Cube, Hole, and Willie Dixon perform (though not together) on Pico.

These experiences are, I suspect, not atypical. Sunset may have more famous restaurants, La Brea better restaurants, and Melrose more restaurants whose chairs have nestled Mira Sorvino's gently rounded flanks. No glossy magazine has ever suggested Pico as an emerging hot street; no real estate ad has ever described a house as Pico-adjacent. The street plays host to the unglamorous bits of Los Angeles, the row of one-stops that supply records to local jukeboxes, the kosher-pizza district, the auto-body shops that speckle its length the way giant churches speckle Wilshire. And while Pico may divide neighborhoods more than it creates them—Koreatown from Harvard Heights, Wilshire Center from Midtown, Beverly Hills–adjacent from not-all-that-Beverly-Hills-adjacent, neighborhoods your cousin Martha lives in from neighborhoods she wouldn't step into after dark—there isn't even a Pico-identified gang.

But precisely because Pico is so unremarked, because it is left alone like old lawn furniture moldering away in the side yard of a suburban house, it is at the center of entry-level capitalism in central Los Angeles, and one of the most vital food streets in the world. Pico is home to Valentino, which specializes in preparing customized Italian food for millionaires, and to Oaxacan restaurants so redolent of the developing world that you half expect to see starved chickens scratching around on the floor; to Billingsley's, a steak house, which could have been transplanted whole from Crawfordsville,

Indiana, and to the Arsenal, a steak house decorated with medieval weaponry; to chain Mexican restaurants, artist-hangout Mexican restaurants, and Mexican restaurants of such stunning authenticity that you're surprised not to stumble outside into a bright Guadalajara sun. Greek and Scandinavian delis still flourish on stretches of Pico that haven't been Greek or Scandinavian since the Eisenhower administration.

I have spent the years since then working my way through the trenches of ethnic cooking in Los Angeles, hitting the first tentative cafés of Thais and Oaxacans and Laotians as they made their way into the country and tracking the increasingly complex restaurant cultures that resulted as well as documenting the vast profusion of Mexican restaurants in East Los Angeles and the extraordinary torrent of Chinese cooking into the San Gabriel Valley, which is now among the most remarkable restaurant communities in the world. It means something, I think, when Thai people learn how to cook Vietnamese noodles for Hong Kong– born teenagers, and as big a fan as I am of authenticity, it probably means something good.

If you live in Los Angeles, you become used to having your city explained to you by others, most frequently by others who jet in for a week or two and report on the world that they find within a few miles of their Beverly Hills hotel suites. Los Angeles is a city of nets, we are told, or a city of angles, the capital of the third world, or a universe captured wholly within the whirring, oversize Rolodexes maintained by Jeffrey Katzenberg. Sometimes visitors will stumble across, say, a Cambodian neighborhood large and self-sustaining enough for a person with modest needs to spend his entire life speaking nothing but Khmer, and naively assume that nobody on the Westside or in Pasadena has experienced such a thing. But we have. And I have been lucky enough to have been able to write about Los Angeles cooking as an Angeleno.

Metropolitan Los Angeles can be an overwhelming place, endless and illogical, stretching for a hundred miles on some axes until the city grid melts into desert, high mountains, or the sea. A hundred different languages are spoken in the hallways of the city's high schools. Do you crave Chinese food? The local Chinese Yellow Pages weighs in at close to 2,500 pages. Have you a taste for Central American cooking? There may be as many as 500 Salvadoran restaurants in central Los Angeles, and at least half of them are pretty good. Los Angeles is the best place in the country to eat the cooking of Thailand and Burma, Guatemala and Ethiopia, Taiwan and any of a dozen states of Mexico.

While sometimes it seems as if the rest of the country still struggles to

redefine the modern American chophouse, Los Angeles is a city where a great meal is as likely to come from Koreatown or the three-million-strong Mexican community as it is from Beverly Hills, a city where inspiration is often as close as the cold case of the local Vietnamese deli.

What I'm trying to say, I think, is that the most authentic Los Angeles experiences tend to involve a mild sense of dislocation, of tripping into a rabbit hole and popping up in some wholly unexpected location. The greatest Los Angeles cooking, real Los Angeles cooking, has first a sense of wonder about it, and only then a sense of place, because the place it has a sense of is likely to be somewhere else entirely. Los Angeles is, after all, where certain parts of town have stood in for Connecticut or Indiana so often on TV that they look more authentic than the real thing; where neighborhoods are called Little India, Little Tokyo, Little Central America, and Koreatown; where a typical residential block might include a couple of Spanish haciendas, a Tudor mansion, two thatched Cotswold cottages, a Palladian villa, and a cream puff of an imitation Loire château.

As people here like to say, often when contemplating a piece of Peruvian-style sushi or one of the Teriyaki Donut stands that have popped up in Quentin Tarantino flicks: *only in L.A.*

Each of the restaurants in this book was visited anonymously and repeatedly, and each of them serves at least one dish that is the best of its kind in the city. Still: Cooks and restaurant owners lead rich, chaotic lives, and any of the information in this book is liable to change for no apparent reason; usually on the day you've driven 35 miles to taste the crawfish étouffée.

SOURCES & ACKNOWLEDGMENTS (IN ORDER OF APPEARANCE)

Our contributors hail from many eras of L.A. literary life and write from many different vantage points. They're all in good company.

ANN ELLIOTT CUTTING is a Los Angeles photographer whose recent exhibitions include "Art of Science" at California Institute of Technology (2017); *Green* at the Center for Fine Art Photography, Fort Collins, Colorado (2012); *Project 5* at the Stephen Cohen Gallery (2010); *I Spy Toy Camera Exhibition*, Hollywood (2009); and *Snap Too* at Armory Center for the Arts, Pasadena (2009). An associate professor in the photography department at ArtCenter, she also teaches and is an Advisory Board member at Los Angeles Center for Photography. cutting.com.

PATRICIA FREEMAN is a writer/editor who has been based in Los Angeles, New York, and Portland. She has been a senior staff writer for the *Los Angeles Herald-Examiner*, staff writer/ editor for *People* magazine, a contract writer for Sunset Publishing, and a columnist for *L.A. Style*. She holds a Master of Studies in Law from Yale Law School, where she was a recipient of the Yale Fellowship in Law for Journalists, and has taught journalistic writing at Rochester Institute of Technology and journalistic practice and ethics at Mt. Hood Community College.

RIVER GARZA is a self-taught mixed-media artist from Gardena, California. His work has been influenced by his urban upbringing and connection to his tribal community in L.A., and he cites the influence of his family's Tongva and Mexican heritage in his work, which has been seen at Self Help Graphics & Art. He is currently pursuing his master's in sociology at California State University, Northridge. rivergarza.com/work.

JONATHAN GOLD, the first food critic to win the Pulitzer Prize for Criticism, did just that in 2007 for his "zestful, wide-ranging restaurant reviews, expressing the delight of an erudite eater." A native Angeleno, he was a proofreader at *L.A. Weekly* while still a student at UCLA, and within a few years wrote music and restaurant reviews as well. His "Counter Intelligence" column ran from 1986 to 1990, when he moved it to the *L.A. Times*, where it appeared until 1996. In 1999, he and his wife, editor Laurie Ochoa, moved to *Gourmet* magazine, then later returned together to *L.A. Weekly* and revived "Counter Intelligence." Gold published a collection of his columns in 2000, was profiled in *The New Yorker* in 2009, was a National Magazine Award finalist for criticism, was the subject of the 2015 film documentary *City of Gold*, and was a frequent James Beard Award nominee or winner from 1996 until his death in 2018.

ALEXANDRA HEDISON is an L.A.-based photographer committed to visual narratives as metaphors for themes of impermanence and change. She most recently exhibited *The In Between* at H Gallery in Paris and at Von Lintel Gallery in Los Angeles. Her work has been shown internationally, including solo shows at Portugal's Centro Cultural de Cascais, Photo London, and Paris Photo. alexandrahedison.com.

GILBERT HERNANDEZ was a child when Don Normark (see below) photographed his home neighborhood, and he was one of *los desterrados* (the uprooted) who kept in touch with one another through the years after its destruction. Normark interviewed him in 1997 for his book *Chavez Ravine, 1949: A Los Angeles Story* as well as for a subsequent documentary.

WARREN HILL is a photographer who grew up in Philadelphia, the scene of one of his earliest memories: going to a club with his mother and seeing a woman on top of a bar playing saxophone. Passionate about photography since age eight, he always had his camera on hand, shooting in Philadelphia, where he managed a record store and was road manager for a group called The Futures, and then in L.A., where he became an Emmy Award–winning television cameraman. When a fire wiped out his garage darkroom, he turned away from still photography for years, but he returned after retirement and began capturing performances by artists of the L.A. blues and jazz scene. An exhibit of his work, *Power and Persistence: Grassroots Activists and Blues Musicians*, was presented at Venice Arts in 2016. warrenhillphoto.com.

KOVI KONOWIECKI was born in Long Beach, California. He holds a BA in Media Communications from Wake Forest University and an MA in Photography from University of the Arts London. After playing professional soccer in Europe, he turned to photography as a way to document the things around him and shed light on different aspects of his identity. He was shortlisted for the 2016 Taylor Wessing Photographic Portrait Prize and has been featured on platforms such as i-D, *British Journal of Photography,* and *The Guardian*. kovikonowiecki.com.

LOU MATHEWS is an L.A.-based novelist, short-story writer, and playwright, as well as a former journalist, magazine editor, and mechanic. He was also a restaurant reviewer for seven years and forty-three pounds. Mathews has received Pushcart prizes, a Katherine Anne Porter Prize, and National Endowment for the Arts and California Arts Commission fellowships in fiction. His stories have been published in *Black Clock, Tin House, New England Review*, forty-plus other literary magazines, ten fiction anthologies, and several textbooks. His first novel, *L.A. Breakdown*, was an *L.A. Times* "Best Book." He has taught in the UCLA Writers' Program since 1989 and was the recipient of a 2018 UCLA Extension Distinguished Instructor Award. Mathews began writing *L.A. Breakdown* as an undergraduate at UC Santa Cruz. After graduation, he worked as a mechanic until he was nearly forty. The novel was published when he was fifty-three. writers.uclaextension.edu/instructors/lou-mathews/.

CONTRIBUTORS

CAREY McWILLIAMS wrote many books, including *Factories in the Field* (1939), *Brothers Under the Skin: African-Americans and Other Minorities* (1943), *Prejudice: Japanese-Americans, Symbol of Racial Intolerance* (1944), *Southern California: An Island on the Land* (1946), and *A Mask for Privilege: Anti-Semitism in America* (1948). He was also a lawyer and public servant (California Division of Immigration and Housing), chaired the Sleepy Lagoon Defense Committee in the early 1940s, and was editor of *The Nation* from 1955 to 1975.

DON NORMARK was a nineteen-year-old student in 1949 when he was welcomed by the residents of Chavez Ravine to take photographs of their day-to-day activities. Some of the resulting pictures appeared shortly after in a LACMA exhibition called *Photography Mid-Century*.

In 1997, Normark, who had built a career as an editorial photographer, especially for *Sunset* magazine, learned that members of the families who had been displaced still kept in touch. He arranged to share his photos and interview some of those depicted for his 1999 book, *Chavez Ravine, 1949: A Los Angeles Story*, and the 2004 documentary of the same title.

LISA SEE is a best-selling author of fiction and nonfiction, including the family history *On Gold Mountain: The One-Hundred-Year Odyssey of My Chinese-American Family* (1995); the historic novels *The Tea Girl of Hummingbird Lane, Snow Flower and the Secret Fan, Peony in Love*, and *Shanghai Girls*; and the mysteries *Dragon Bones, The Interior*, and *Flower Net*. Her books have been published in thirty-nine languages. She wrote the libretto for an opera based on *On Gold Mountain*, has curated museum exhibitions, and designed a walking tour of L.A.'s Chinatown. She is a member of the board of directors of the Los Angeles Opera. lisasee.com

HARRY SHEARER is the author of the books *Man Bites Town, Not Enough Indians*, and *It's the Stupidity, Stupid*. Now a resident of New Orleans, he was born in L.A. and lived for many years in Santa Monica, where he did a live broadcast from his home studio of "Le Show" on radio station KCRW. "Le Show" continues as a weekly broadcast from public radio station WWNO. Shearer began his career as a child radio actor on *The Jack Benny Show* and has a Hollywood Walk of Fame star in the radio category. He has also worked extensively in TV and film. He is the voice of a number of characters on *The Simpsons*, was a member of *This Is Spinal Tap*, and has been a member of *The Credibility Gap, The Fernwood 2 Night* writing team, and *The Saturday Night Live* cast. In 2010, he directed, produced, and narrated the documentary film *The Big Uneasy*. harryshearer.com.

R.J. SMITH'S books include *American Witness: The Art and Life of Robert Frank* (2017), *The One: The Life and Music of James Brown Mar* (2012), and *The Great Black Way: L.A. in the 1940s and the Lost African-American Renaissance* (2009). He has been a senior editor at *Los Angeles* magazine, a columnist for *The Village Voice*, and a staff writer for *Spin*.

C.A. STORKE was the publisher and editor of the *Los Angeles Daily Herald*, which he founded in 1873 with the backing of his father-in-law and lost to creditors in 1874. After losing the paper, he returned to Santa Barbara, became a lawyer, and was elected to the State Legislature in 1883 and 1887. (His son Thomas More Storke became an owner and publisher of Santa Barbara newspapers, winning the Pulitzer Prize in journalism for Editorial Writing in 1962.)

STUART TIMMONS was a journalist, activist, historian, and film-festival co-founder (OUTfest). He wrote the biography *The Trouble with Harry Hay: Founder of the Modern Gay Rights Movement*, which was published in 1990. He co-authored, with Lillian Faderman, *Gay L.A.: A History of Sexual Outlaws, Power Politics, and Lipstick Lesbians*, which was published in 2006 and received two Lambda Literary Awards. The first executive director of the ONE National Gay and Lesbian Archives at USC, he wrote for *The Advocate* and *L.A. Weekly*. He created walking tours of LGBTQ historic sites in Silver Lake and DTLA and, with Jason Jepp, created a West Hollywood history tour with on-site performances. whitecraneinstitute.org/books.

ROSANNE WELCH, PHD, is the editor of *When Women Wrote Hollywood: Essays on Female Screenwriters in the Early Film Industry* (2018), the author of *Why the Monkees Matter:*

Teenagers, Television and American Pop Culture (2016), and the co-editor of *Women in American History: A Social, Political, and Cultural Encyclopedia* (2016), among others. She has written for television (*Touched by an Angel, Picket Fences*) and teaches the History of Screenwriting and One-Hour Drama for the Stephens College MFA in Screenwriting. Welch serves as Book Reviews editor for the *Journal of Screenwriting* and is on the Editorial Advisory Board for *Written By*, the magazine of the Writers Guild of America, West. welchwrite.com/rwelch.

MARITTA WOLFF was a novelist whose career began in 1940, when her class-project novel at the University of Michigan won the school's Hopwood Prize and was published by Random House, becoming a best-seller when she was twenty-two. The novel, *Whistle Stop*, went on to become a Hollywood movie, as did her second novel, *Night Shift* (as *The Man I Love*). She published four other novels between 1943 and 1962. She completed her last one, *Sudden Rain*, in 1972 but kept it tucked away in her refrigerator following a disagreement with a publisher. Her family published it after her death in 2002.

KAREN TEI YAMASHITA is the author of *Through the Arc of the Rain Forest, Brazil-Maru, Tropic of Orange, Circle K Cycles*, and *I Hotel*. The last was a finalist for the National Book Award and received the California Book Award, the American Book Award, the Asian/Pacific American Librarians Association Award, and the Association for Asian American Studies Book Award. She is Professor of Literature and Creative Writing at the University of California, Santa Cruz. She has been a US Artists Ford Foundation Fellow and co-holder, with Bettina Aptheker, of the UC Presidential Chair for Feminist Critical Race and Ethnic Studies.

MY HOMETOWN

Want to get a posse of native Angelenos riled up? All you need to do is send a journalist from New York or San Francisco or Chicago to spend a week or two in our city and then publish their think piece on the "real" L.A. Oh boy, do we love that.

So when dear old pal Susan LaTempa, my former editor at two hometown magazines (*L.A. Style* and *Westways*) and collaborator on two books, pitched me her idea for a series of books called Paperback L.A., it took me about five seconds to say, "I'm in." She'd been collecting favorite bits of writing about her beloved city for years. She gets it. And since my roots here are six generations deep, with settled-here adult children adding another tangle of roots, I get it, too.

Now we're three books in to this groundbreaking series, and no pair of mamas has been more proud of their babies. Susan has done an extraordinary job of unearthing L.A. treasures in words and images, from last week and 150 years ago. What a joy it's been to start my work day reading something she'd discovered for one of these books: Lisa See's masterful description of her family's glamorous 1940s Chinatown restaurant, Jim Gavin's dips in a Long Beach tract-house pool, Vin Scully's call of a legendary Dodgers game, Eve Babitz's teen summers on the "cheap" beach, Naomi Hirahara's tales of Terminal Island's fishing community, Harry Shearer's droll musings on the smells of L.A., Chester Himes's satiric story set in the Ritzmore Hotel, so obviously the Biltmore, Jonathan Gold's exploration of Pico Boulevard…and more and more and more.

CODA
COLLEEN
DUNN BATES

I wish for you, dear reader, all the delight and discovery that I have experienced in this book, and in its two siblings. They are crystals refracting dozens of brilliant glimpses of my beloved hometown, books I will be dipping back into for many years to come.